MASTERS OF THEIR CRAFT

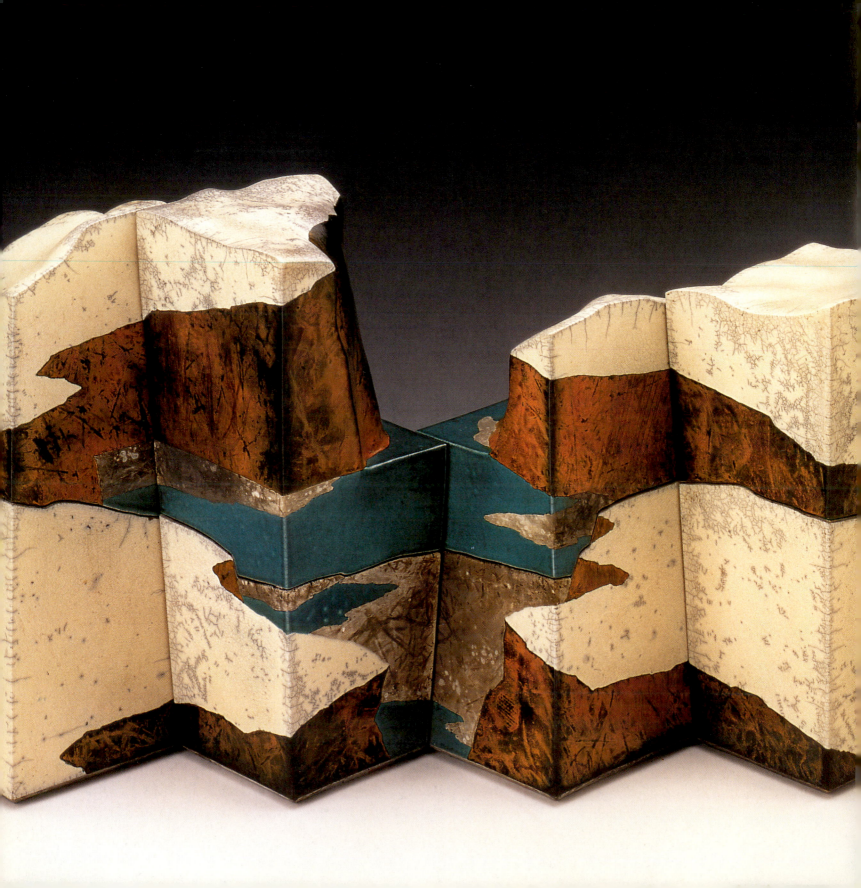

MASTERS OF THEIR CRAFT

Highlights from the Smithsonian American Art Museum

Kenneth R. Trapp

Smithsonian American Art Museum

Masters of Their Craft: Highlights from the
Smithsonian American Art Museum

By Kenneth R. Trapp

Chief, Publications: Theresa J. Slowik
Designers: Robert Killian, Steve Bell
Editor: Susan Efird

Library of Congress Cataloging-in-Publication Data

Trapp, Kenneth R.
Masters of Their Craft : highlights from the
Smithsonian American Art Museum /
Kenneth R. Trapp.
 p. cm.—(Highlights from the Smithsonian
American Art Museum)
 Includes index.
 ISBN 0-937311-58-8 (pbk.)
1. Decorative arts—United States—History—20th
century—Catalogs. 2. Decorative arts—Washington,
D.C.—Catalogs. 3. Smithsonian American Art
Museum—Catalogs. I. Title: Highlights from the
Smithsonian American Art Museum. II. Smithsonian
American Art Museum. III. Title. IV. Series.
 NK808 .T73 2003
 745'.0973'074753—dc21
 2002154514

Printed and bound in Spain

First printing, 2003
1 2 3 4 5 6 7 8 9 / 08 07 06 05 04 03 02 01

Photograph credits: pp. 8–9, 11, 15, 17, 19, 21, 23, 25,
27, 31, 33, 35, 37, 38–39, 41, 43, 45, 46–47, 51, 53, 55,
56–57, 61, 66–67, 69, 71, 73, 77, 79, 83, 85, 87, 89, 95,
97, 99, 101, 103, 105, and 107, Bruce Miller; p. 13,
Michael Fischer; pp. 29, 49, 81, and 93, Lyle Peterzell;
pp. 59, 63, 65, 91, and 109, Gene Young; and pp. 74–75,
Edward Owen.

Cover: Dale Chihuly, *Cobalt and Gold Leaf Venetian*, 1993,
blue glass with gold leaf. Smithsonian American Art
Museum, Partial and promised gift of Elmerina and
Paul Parkman (see page 29).

Frontispiece: Wayne Higby, *Temple's Gate Pass* (detail),
1988, earthenware. Smithsonian American Art
Museum, Gift of KPMG Peat Marwick (see pages
46–47).

Masters of Their Craft is one of five exhibitions presented as
Highlights from the Smithsonian American Art Museum,
touring the nation through 2005.

Foreword

Working in a museum, I have come to appreciate the joys of repeated encounters and easy intimacy with works of surpassing tranquility or great power. I also love the surprise of the unexpected when I see something new or challenging in another museum. Visitors here and abroad share these same experiences, encountering artworks as familiar friends in settings close to home or unanticipated discoveries in different places.

The Smithsonian American Art Museum is the nation's museum dedicated exclusively to the art and artists of the United States. The collections trace the country's story in art spanning three centuries, and its in-depth resources offer opportunities to understand that story better. While our main building undergoes extensive refurbishment, we have a great opportunity to share our finest artworks with everyone across the nation.

From 2003 through 2005, five traveling shows will feature four hundred works, including modern African American art, landscape photography, master drawings, contemporary crafts, and pre-1850 quilts. Readying this wave of ambassadors has called upon the talents and enterprising spirit of the entire staff, especially the curators, conservators, registrars, and editors. I would like to thank all who have worked so hard to make possible this ongoing initiative to share our collections during the renovation period. We are also grateful for the support of the Smithsonian Special Exhibitions Fund and numerous supporters as

well as to the several dozen American museums who will graciously host these traveling exhibitions.

The objects in this exhibition hint at the vast creative spirit that is a hallmark of contemporary crafts. Marked by diversity of artistic expression and approaches to materials, the contemporary crafts movement is a fairly recent phenomenon, although the bloodlines of the art can be traced to prehistoric time. Crafts emphasize materiality—clay, glass, fiber, wood, metal—and the technical means by which the properties of these materials are manipulated. Evolving from ancient workshops, medieval guild trades, and the Industrial Revolution that gave rise to the very industries we associate with crafts today, crafts often pay homage to function at the same time that they discard utility as a concern.

We invite you to revisit our collections as familiar friends when they are installed in the museum's beautifully restored building in Washington, a historic artwork in its own right. There you will encounter expanded spaces for exciting special exhibitions and for the permanent collection's showcasing, including the Luce Foundation Center for American Art. This open-storage facility will house five thousand paintings, sculptures, and craft and folk objects previously inaccessible to the public. A new publicly visible conservation lab will reveal the complex processes of restoring artworks, while an array of public programming and educational resources, onsite and online, will also enhance the experiences of visitors and researchers alike. We look forward to welcoming you to the new Smithsonian American Art Museum.

Elizabeth Broun
The Margaret and Terry Stent Director
Smithsonian American Art Museum

ABRASHA

born Netherlands 1948

Hanukkah Menorah

1995, stainless steel, silver, and gold
6 ⅞ x 17 ¼ x 3 ⅞ in.
Smithsonian American Art Museum, Gift of the James Renwick Alliance and the artist in memory of the artist's father, Solomon David Staszewski

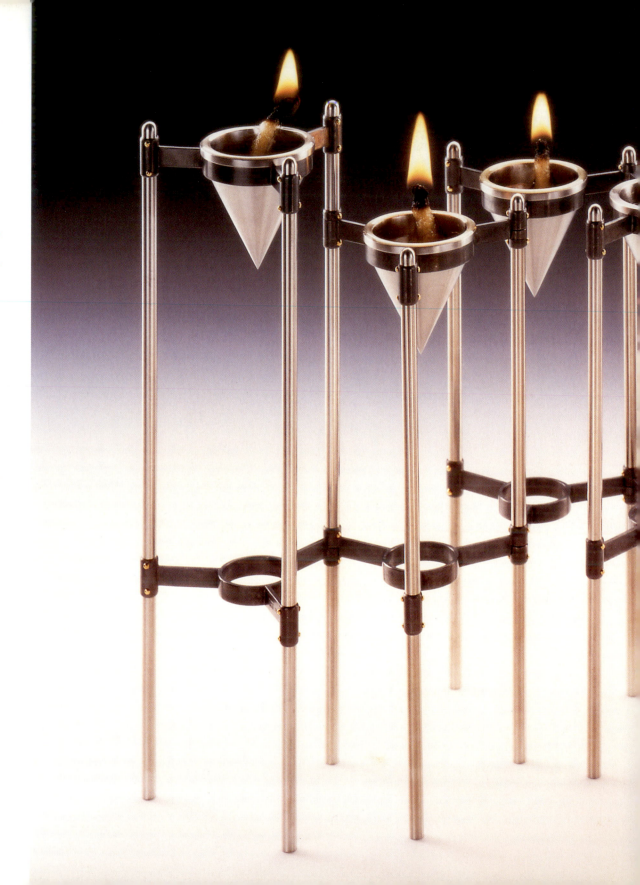

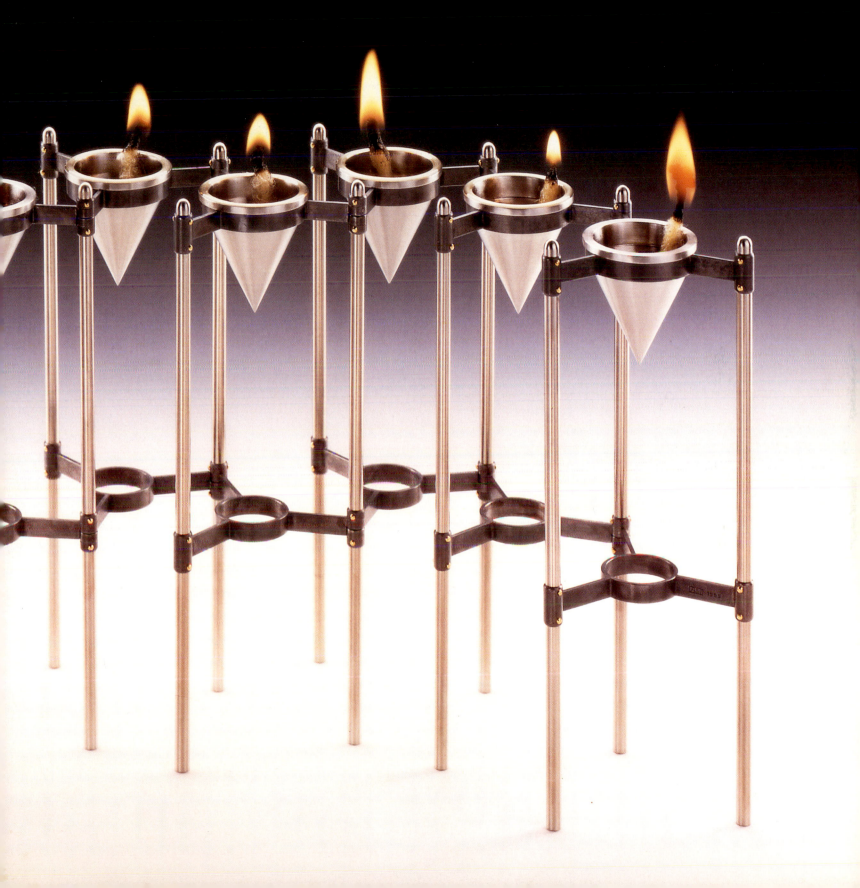

HANK MURTA ADAMS

born 1956

Gomer

1990, yellow glass
and metal
29 ¼ x 17 ¾ x 13 ¼ in.
Smithsonian
American Art
Museum, Gift of the
James Renwick
Alliance on the
occasion of the
twenty-fifth
anniversary of the
Renwick Gallery

Hank Murta Adams uses cast glass to create powerful busts that depart from tradition. Historically, busts were molded in clay, carved in stone, or cast in metal. They commonly paid tribute to their sitters by either idealizing them or representing them in a realistic way. Adams's busts, however, are consciously antiheroic and repulsive, the antithesis of an idealized or naturalistic portrayal.

Among his busts, *Gomer* is unusual in its color. Only cadmium yellow glass was available to Adams when he created the sculpture. Beautiful and compelling, the color clashes with the studied ugliness of the piece, heightening the tension that permeates it. Adding further to its disquiet is the name "Gomer," which is associated with a bumpkin.

Gomer appears to be more a thing than a humanlike creature. Recalling something from a science-fiction film, it seems caught in a moment of transition. Is it in the process of being created or is the creature dissolving to a former state?

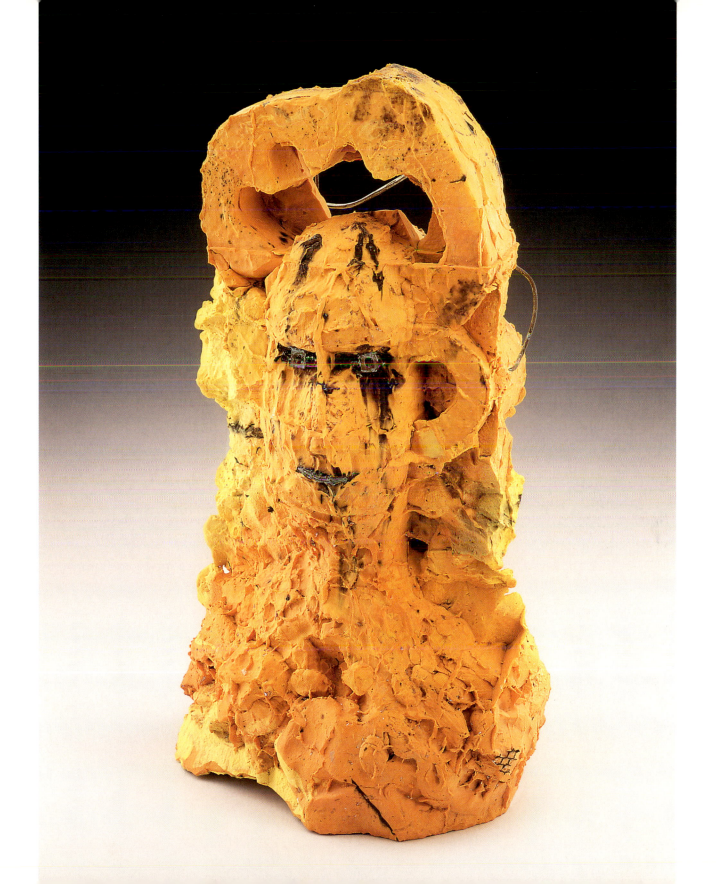

MARY ADAMS

1917 Canada–1999 USA

Wedding Cake Basket

1986, sweetgrass
and ash splint
25 ½ x 15 ¾ in.
Smithsonian
American Art
Museum, Gift of
Herbert Waide
Hemphill Jr.

A member of the Mohawk Nation of the Iroquois Confederacy, Mary Adams bridged the worlds between her Indian heritage and her Catholicism and the white culture that surrounded her. Orphaned at age ten, the artist began to make baskets to support her brother and herself. After a long career in which she achieved mastery of these skills, Adams made *Wedding Cake Basket* in 1986 for the twenty-fifth wedding anniversary of one of her children. It is composed of four layers that rise in a conical pyramid ending in a bell-shaped top crowned by arches that support two bells. Her masterpiece weaves the western European ritual of the wedding cake with splint basket making practiced by the Iroquoian peoples since the late eighteenth century. With its prominent spiral projections, the work's surface texture suggests the luscious cream frosting of the most elaborate wedding confections.

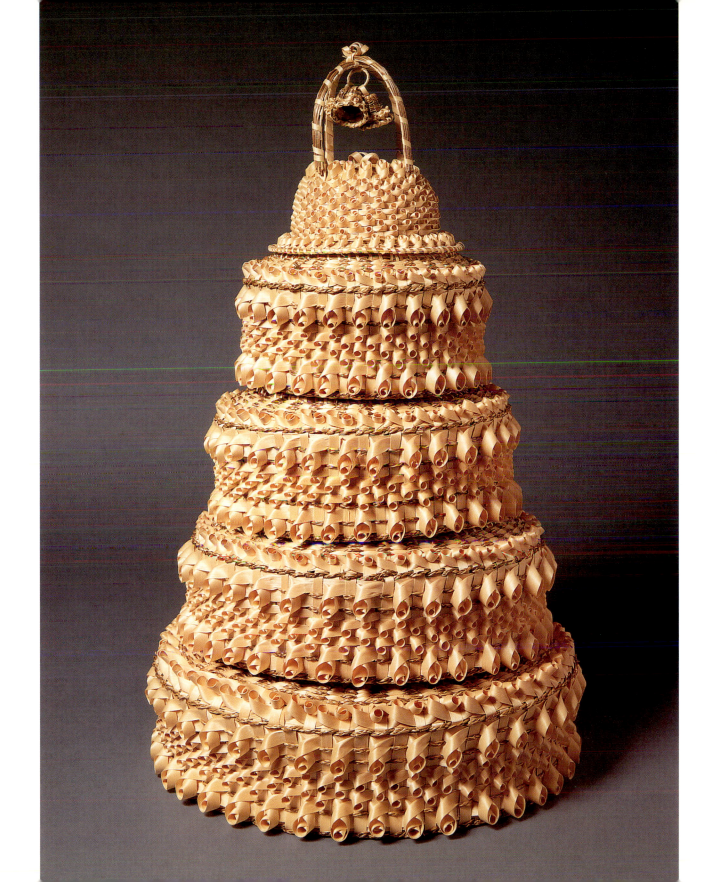

RENIE BRESKIN ADAMS

born 1938

Fear, Laughter and the Unknown

1978, cotton
and linen
30 x 23 ¾ in.
Smithsonian
American Art
Museum, Gift of the
Council of American
Embroiderers on
the occasion of the
twenty-fifth
anniversary of the
Renwick Gallery

At first glance this lush embroidery appears to be a small Oriental carpet. Indeed, the basic pattern, the colorful but muted palette, and the dense nubby pile were inspired by the time-honored tradition of carpet weaving in western and central Asia. Using whimsical, yet disturbing, cartoon images, Renie Breskin Adams infuses the embroidery with autobiographical details. Although unreadable, these cryptic ideograms convey to the viewer that a story is being told.

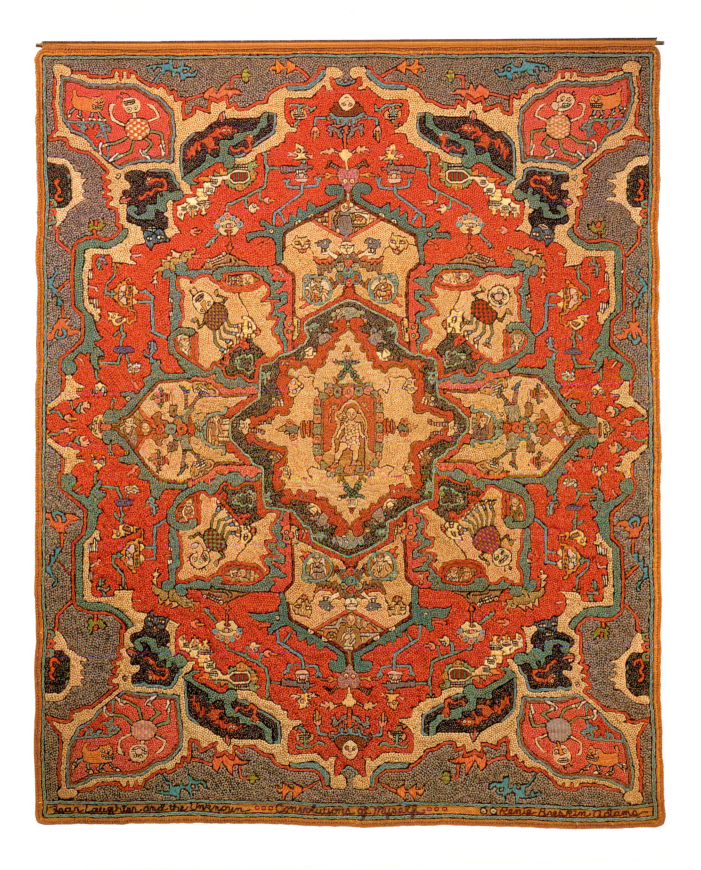

ROBERT ARNESON
1930–1992

Breast Trophy

1964, stoneware
19 ¾ x 11 ¾ x 8 in.
Smithsonian
American Art
Museum, Museum
purchase made
possible by the
Smithsonian
Institution
Collections
Acquisition Program

With its sagging female breasts and dark, extended nipples, this work contradicts the idea of commemorative trophies. But to understand the meaning of *Breast Trophy* we must separate the messenger from the message. Robert Arneson's observation of human behavior and American cultural mores—that men and women have an obsession with female breasts—inspired this trophy and its pithy social comment. Arneson also brings to our attention the discomforting truth that women are often turned into objects and reduced to a specific body part. The most evident example of this cultural phenomenon is the phrase "trophy wife." The title *Breast Trophy* transforms the piece into a witty visual pun.

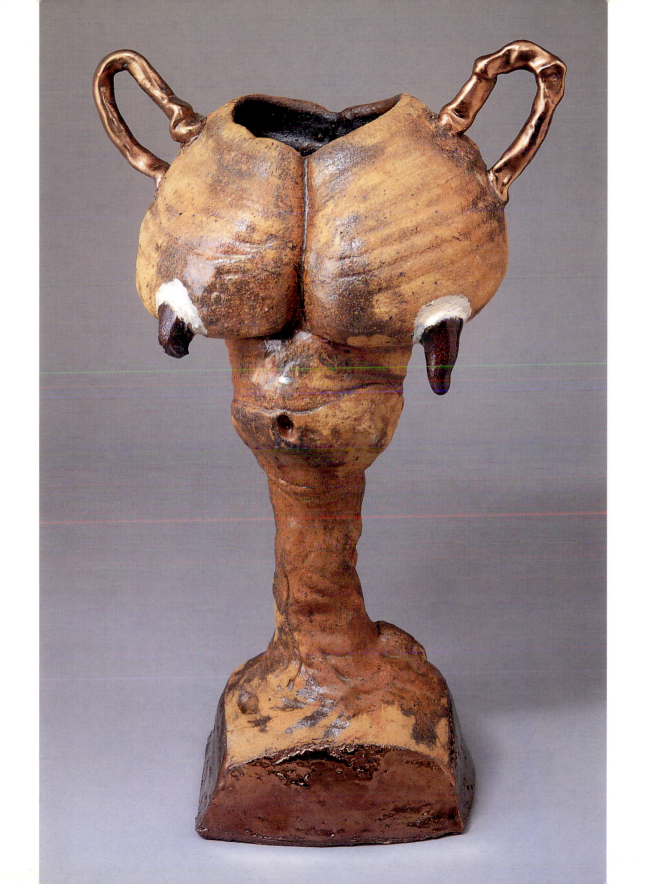

RALPH BACERRA

born 1938

Teapot

1989, earthenware
16 1/4 x 12 3/8 x 9 5/8 in.
Smithsonian
American Art
Museum, Gift of the
James Renwick
Alliance and museum
purchase through the
Smithsonian Institution
Collections Acquisition
Program

Ralph Bacerra's *Teapot* is one in name only. The upright, cylindrical body of the piece does not look like the traditional spherical Western teapot at all, but more like a coffeepot. More importantly, Bacerra did not create the teapot to brew tea but to be enjoyed as a purely visual and tactile experience.

Teapot is a study of contrasting shapes, colors, and textures. The tree-trunk body and twig handle, spout, finial, and rock base have a rustic appearance while the textile-inspired decoration, rich colors, and metallic finishes look refined. In addition, dull textures juxtaposed with glassy finishes create a lively effect. Although created from clay, the piece is indebted to artistic traditions in wood, textiles, and metals.

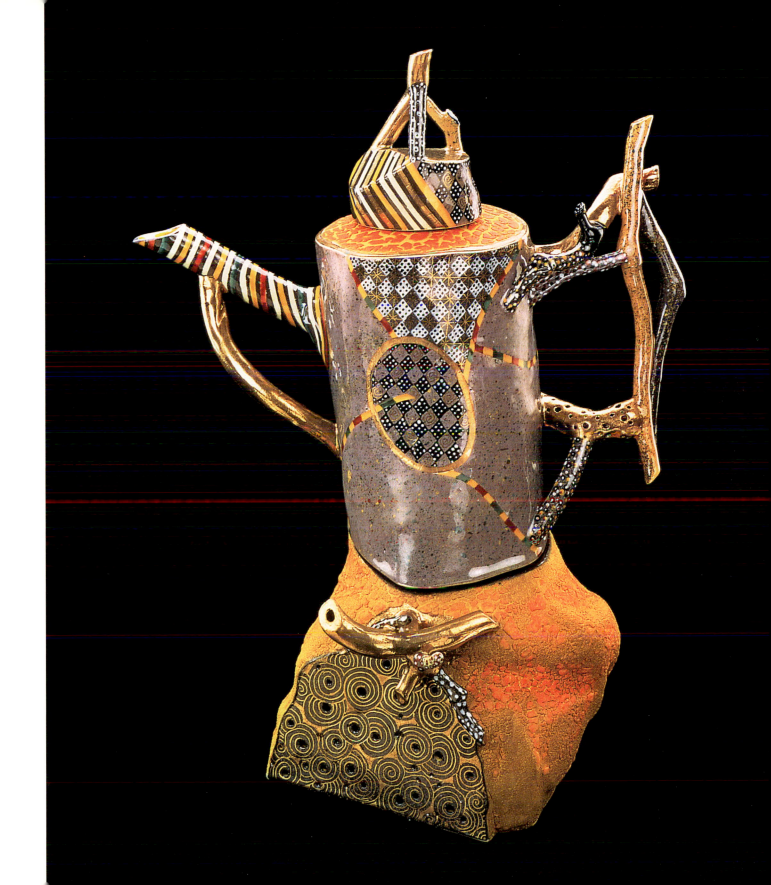

BROTHER THOMAS
BEZANSON

born Canada 1929

Large Vase

2000, porcelain
13 ¼ x 17 in.
Smithsonian
American Art
Museum, Gift of
Ann L. Bronfman

Brother Thomas Bezanson is a consummate master of his craft, a "potter's potter." His motivating interest is to create the perfect marriage of form and finish. The shape of this magnificent vase is full and satisfying in its volume and silhouette. It is impossible to consider the piece and not relate it to the human body. Rising from a short foot, the bulbous vessel begins to swell, its very tumescence hinting at a life force. Its erotic subtlety recalls the ripeness of the mature male body and its potential for renewing life. Completing the vase is the rich mustard-yellow, elm-ash glaze that flows in streaks and pools.

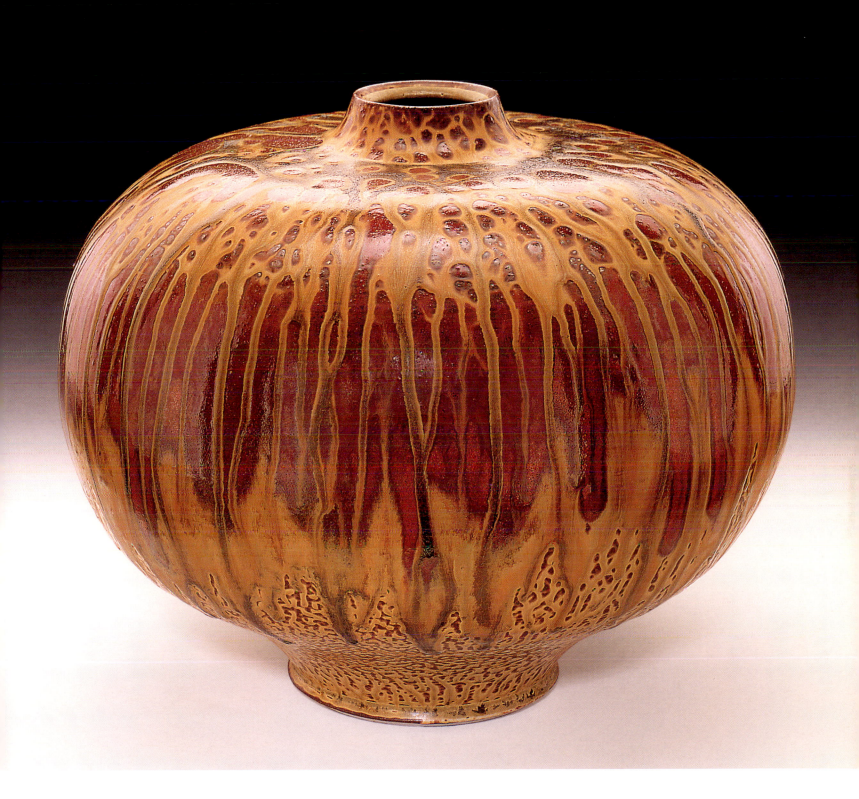

JOANNE SEGAL BRANDFORD
1933–1994

Bundle

1992, rattan, kozo,
nylon, and paint
approx. 24 x 28
x 23 1/2 in.
Smithsonian
American Art
Museum, Museum
purchase through
the Renwick
Acquisition Fund

Woven of rattan, kozo, and nylon, Joanne Segal Brandford's *Bundle* transports the basket-inspired form into the realm of sculpture. Although the sculpture appears static and self-contained, it resonates with an internal dynamic interplay. Strands of fiber loop over and under and into each other to create the sensation of movement and activity. Adding to its visual richness are the pronounced structural lines that hold the piece together. Brandford solved the problem of how to handle the ends of threads by simply tying them into knots, which punctuate the surface of the sculpture.

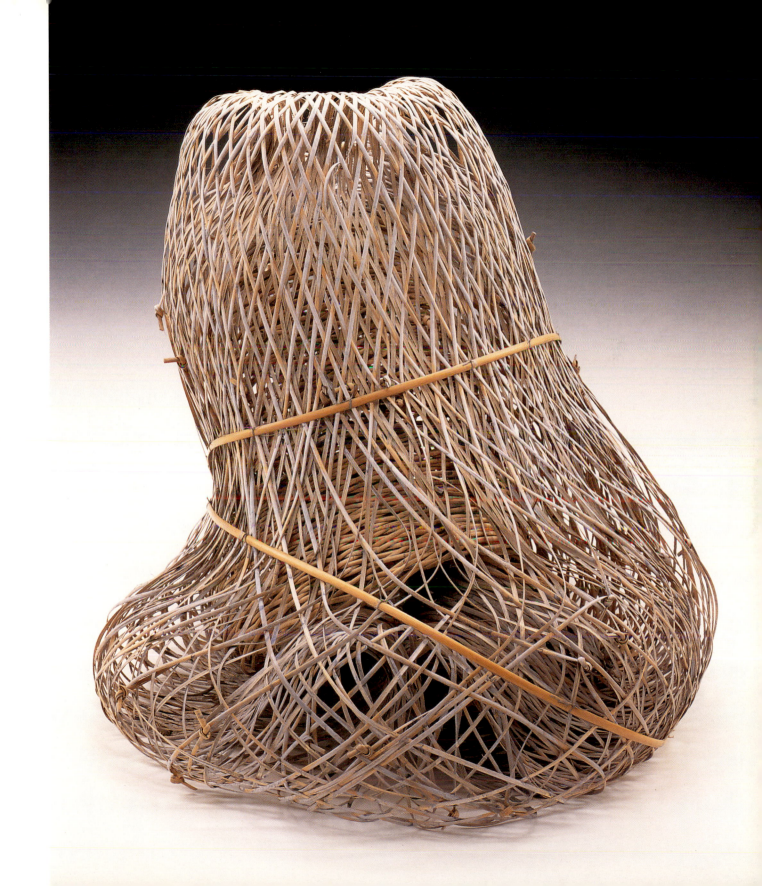

JOHN CEDERQUIST

born 1946

Ghost Boy

1992, various
woods, copper leaf,
and pigments
88 1/4 x 44 1/2 x 15 in.
Smithsonian
American Art
Museum, Gift of the
James Renwick
Alliance, Ronald
and Anne Abramson
and museum
purchase

John Cederquist's sculptures seem to be furniture, but they are, in fact, useless for all practical purposes. Cederquist uses furniture forms, such as chests, desks, tables, benches, and chairs, as points of departure to explore imagery. The artist maintains that the dictum of modern design—form follows function—is incomplete because it fails to incorporate images.

A John Townsend high chest from Newport, Rhode Island, of about 1760 in the Museum of Fine Arts, Boston, inspired *Ghost Boy,* although it is more the semblance of a high chest than an actual chest. Using visual tricks and perspective to create the illusion of furniture, Cederquist combines an august Colonial American high chest with cheap shipping crates. Like a cubist master, the artist fractures and reassembles his high chest as if to understand its components. Cederquist delights in teasing our senses. Is his art the illusion of reality or the reality of illusion?

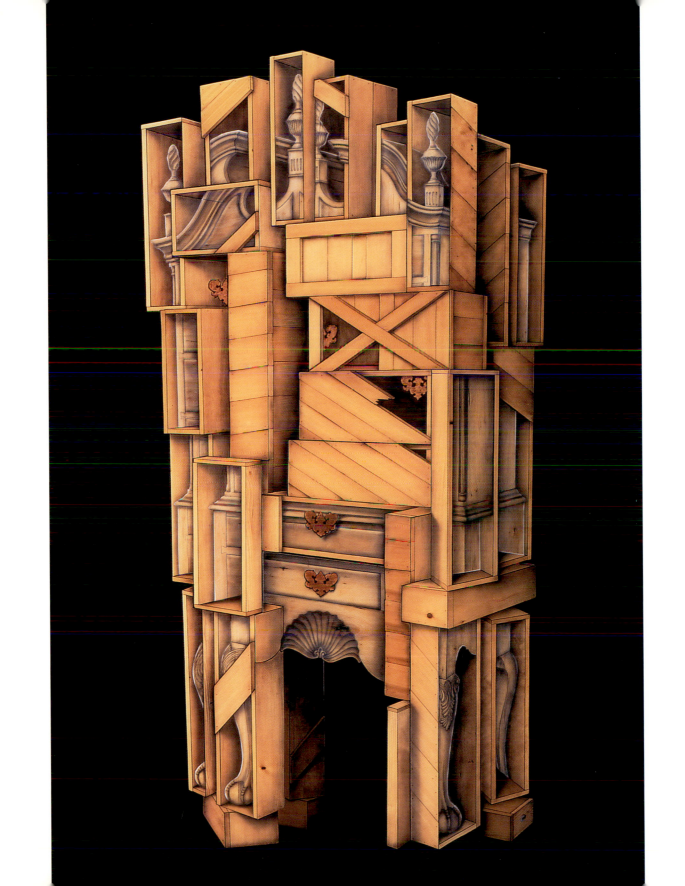

DALE CHIHULY

born 1941

Emerald Green Blanket Cylinder with Cerulean Blue Drawing

1984, colored glass
12 ½ x 8 x 8 ½ in.
Smithsonian
American Art
Museum, Gift of the
James Renwick
Alliance and museum
purchase through the
Smithsonian
Institution Collections
Acquisition Program

As the title suggests, color is the singular feature of this simple glass-blown cylinder and the reason for its being. The cylinder is inspired by textiles. Colored glass rods are incorporated into the "fabric" of the form to create loose "drawings." A consummate graphic artist as well as master glass blower, Chihuly is obsessed with spontaneity and with vivid, saturated colors. His art celebrates excess. It is an aesthetic that shouts, "Too much is not enough."

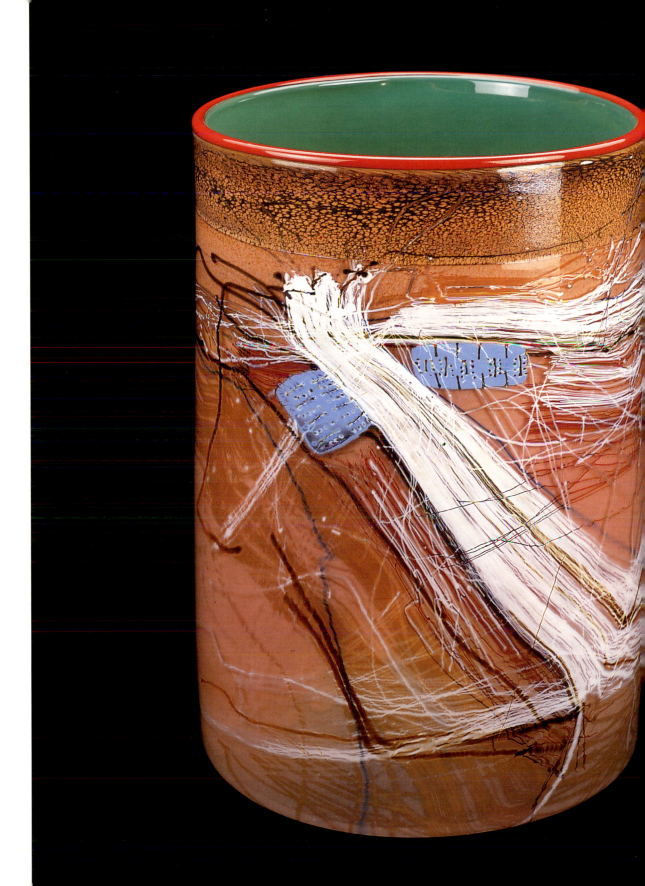

DALE CHIHULY

born 1941

Cobalt and Gold Leaf Venetian

1993, blue glass
with gold leaf
22 x 19 x 19 in.
Smithsonian
American Art
Museum, Partial
and promised gift of
Elmerina and Paul
Parkman

Cobalt and Gold Leaf Venetian has the hallmarks of Dale Chihuly's finest blown glass. The intense, supersaturated cobalt blue glass of this vessel, when lighted, glows with life. Adding to its brilliance is the gold leaf, which concentrates in some areas to suggest pollen floating on water. Chihuly further embellishes the glass with applied leaflike projections that overwhelm the underlying form. Unabashedly decorative, the piece is a perfect example of art for the sake of art, an object made to appeal to the senses.

Chihuly's Venetian series pays tribute to the glass-making traditions practiced in Venice since the fourteenth century. The influence of Venetian techniques on the contemporary studio glass movement in the United States, and in Seattle in particular, is pervasive and strong.

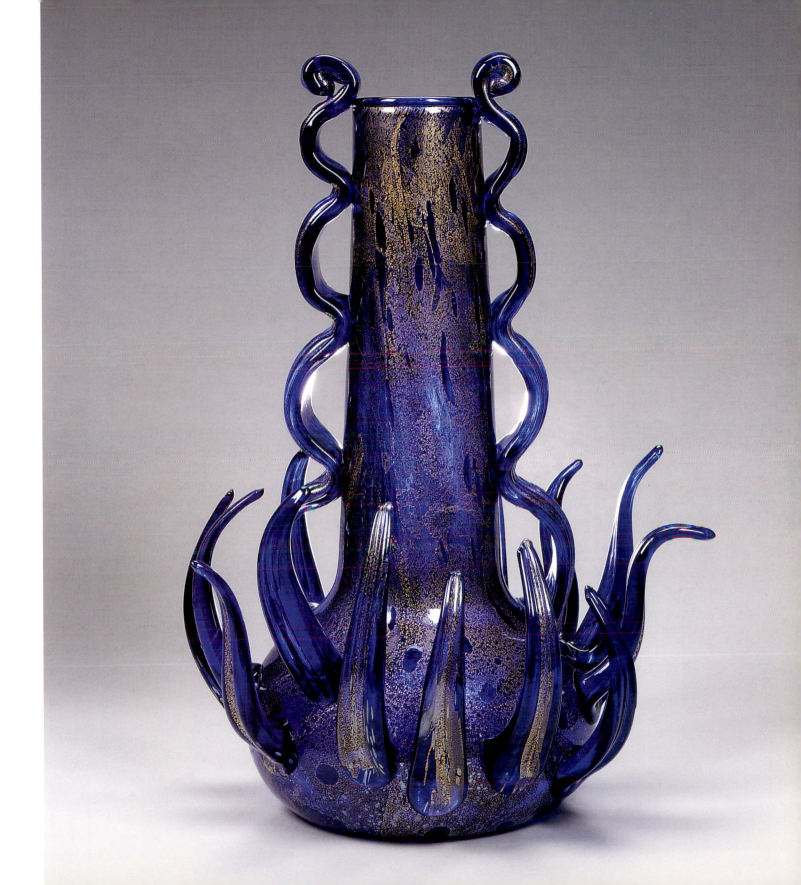

MARGRET CRAVER

born 1907

Muffineer

1946, silver
3 ¾ x 3 x 3 in.
Smithsonian
American Art
Museum, Gift of the
James Renwick
Alliance

A muffineer is a small shaker with a perforated top used to sprinkle salt or sugar on buttered muffins. Once common to the well-set table of the wealthy, today muffineers are mostly collectible curiosities. Margret Craver's muffineer is a one-of-a-kind object that can be contemplated and enjoyed for its uniqueness. In its clean lines and simple forms, this delightful muffineer is clearly indebted to modern industrial design and almost appears to have been mass-produced. However, Craver's master metalworking skills and design sensibility infuse the shaker with a vitality uncommon to manufactured objects.

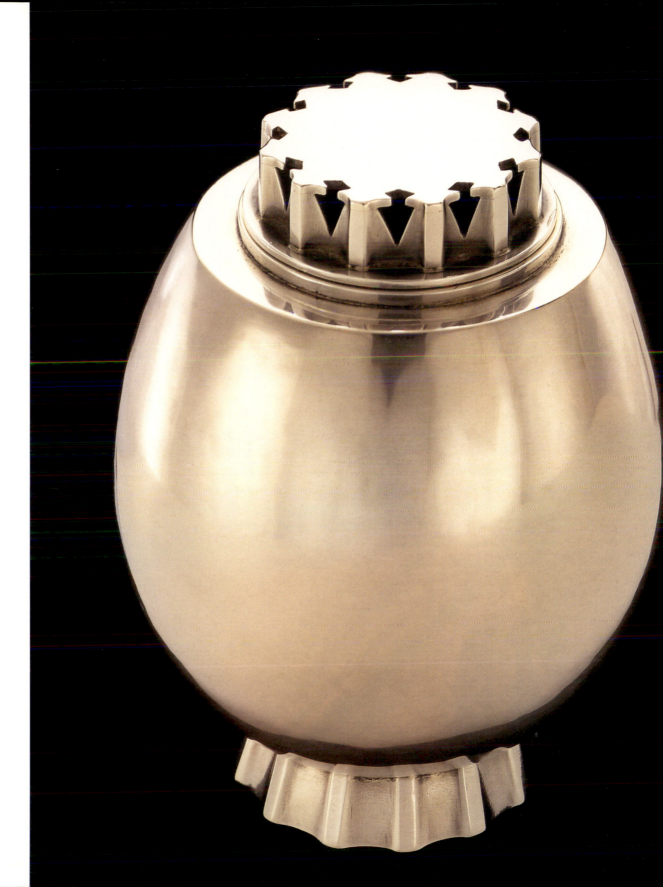

RICHARD DeVORE

born 1933

Untitled Vessel (#403)

1983, stoneware
16 x 12 ½ in.
Smithsonian
American Art
Museum, Museum
purchase

Richard DeVore begins his ceramic pieces with generic shapes—open or conical bowls, plates, and tall upright vessels—then transforms them by emphasizing irregularities and manipulating forms and finishes. References to the human body are common in his ceramics. The uneven forms with slack curves and pinched folds suggest the aging body; the pinkish-beige matte glazes and weblike lines resemble veined, translucent skin. Often his pieces have irregular openings that penetrate more than one layer, recalling the body's orifices. Much like Renaissance memento mori paintings that remind the viewer that all things pass and death comes to everyone, DeVore's ceramics are ultimately a comment on the human condition. Adding to the poignancy of his clay is the subtle eroticism that pervades his art, for the pleasures of the flesh fade with time.

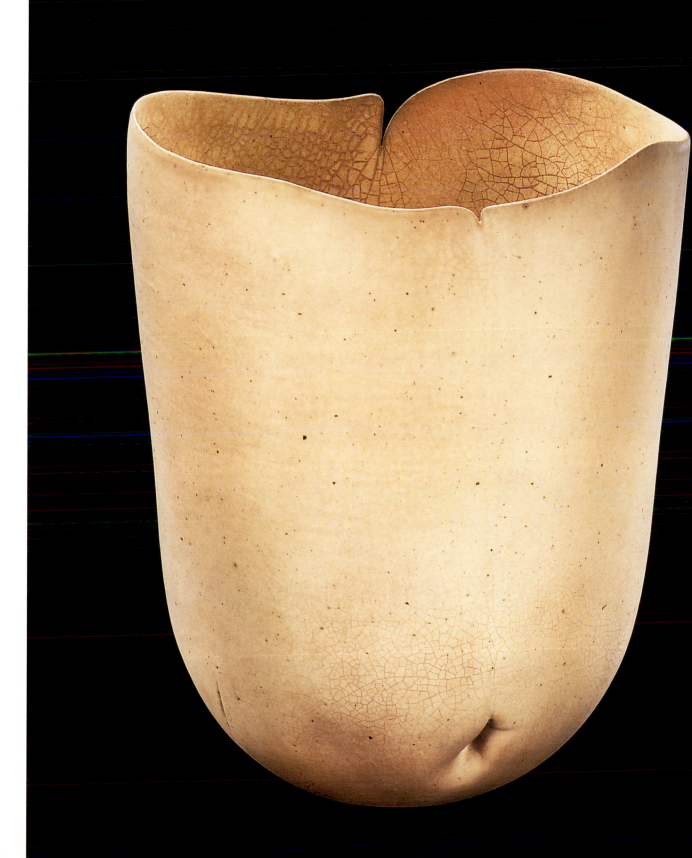

FRITZ DREISBACH

born 1941

Ruby Wet Foot Mongo with Kissing Serpents and Lily Pad

1990, clear and
colored glass
19 ¼ x 19 x 15 ½ in.
Smithsonian
American Art
Museum, Gift of the
James Renwick
Alliance and
museum purchase
through the
Smithsonian
Institution
Collections
Acquisition Program

"I love fluid glass!" Fritz Dreisbach exclaims enthusiastically. The artist's fascination with the movement of the molten material is beautifully realized in the massive vessel *Ruby Wet Foot Mongo with Kissing Serpents and Lily Pad*. Dreisbach began the Mongo series in 1979 in an attempt "to capture and display the fluid, organic feel of hot, molten glass."

The vessel's undulating lines and forms resemble an exotic flower or sea form. Although inert, the glass looks alive, as if it could begin to flow at any moment. Deep within the clear glass are thin threads of colored glass that add interest to the piece. *Ruby Wet Foot Mongo with Kissing Serpents and Lily Pad* is, in essence, a drawing in glass.

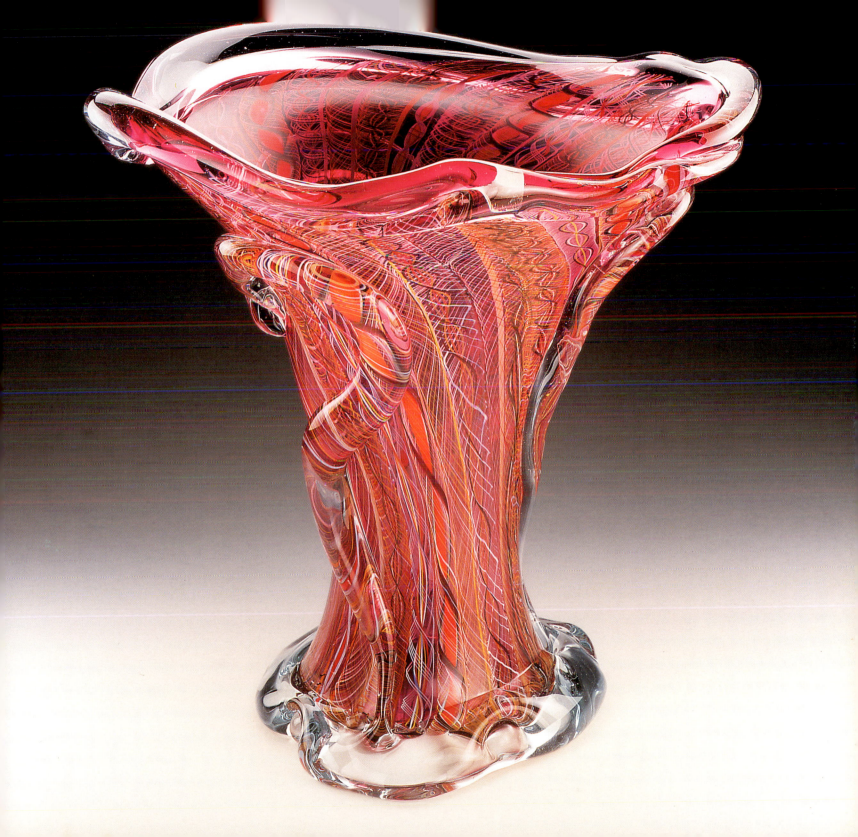

MICHAEL FRIMKESS

born 1937

Ecology Krater II (Out Biking with Aunt Samantha)

1976, stoneware
26 x 26 x 19 ½ in.
Smithsonian
American Art
Museum, Gift of the
James Renwick
Alliance

Ecology Krater II (Out Biking with Aunt Samantha) takes its shape from an ancient Greek krater, a footed vessel with prominent scroll handles and a wide mouth used to mix wine and water. In its form this piece refers directly to the history of ceramics.

Michael Frimkess uses the krater as a vehicle on which to paint his narrative. Encircling the body of the vessel are eight people (one carries a baby) sharing two bicycles built for four. In addition, two girls and a boy ride their own bicycles. The bikers vary widely in age, from the infant to a bearded, older man. One girl yells out, "Hi Auntie Samantha," and a man shouts, "Junior Bye." The group frolics in the open air of Southern California, perhaps in east Los Angeles where Frimkess was born and raised.

The title, *Ecology Krater II*, refers to the series of animals seen below the flat lip of the krater. On one side are endangered species—white rhinoceros, American bison, bald eagle, mountain gorilla, and gray whale—while on the opposite side, painted in pairs, are nonendangered, more common species—rats, rabbits, mice, and an unidentified rodent. Although the decorative schemes seem unrelated, perhaps the opposite is true: we go about our daily lives oblivious to the reality that many species are quietly disappearing forever.

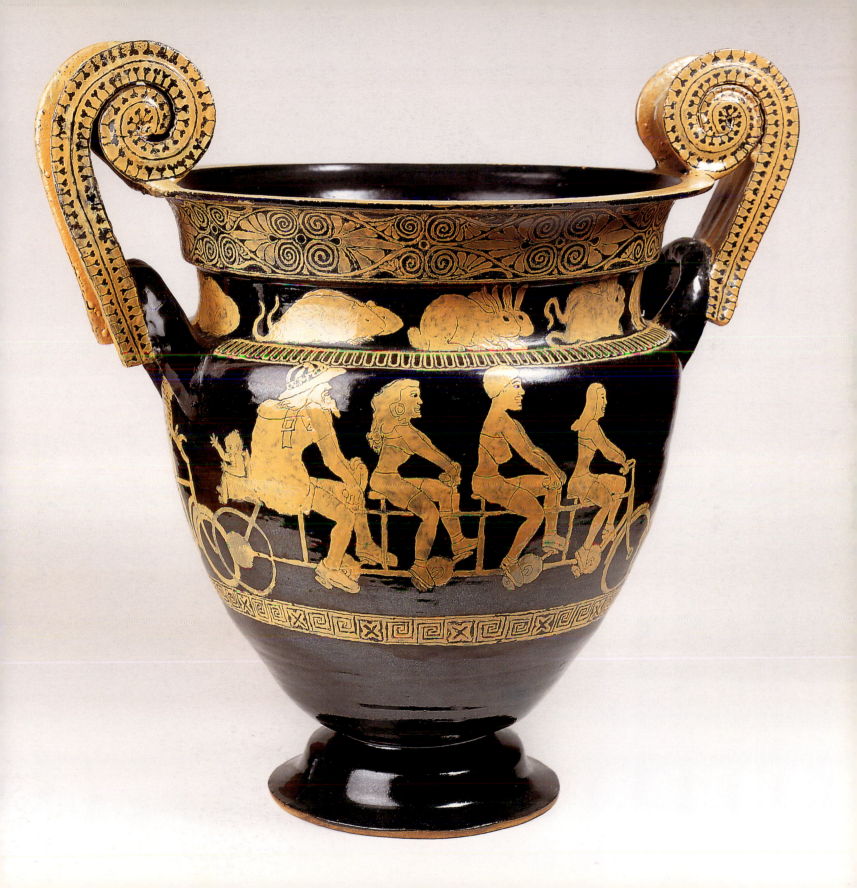

LARRY FUENTE

born 1947

Game Fish

1988, mixed media
51 ½ x 112 ½ x 10 ¾ in.
Smithsonian
American Art
Museum, Gift of the
James Renwick
Alliance and
museum purchase
through the
Smithsonian
Institution
Collections
Acquisition Program

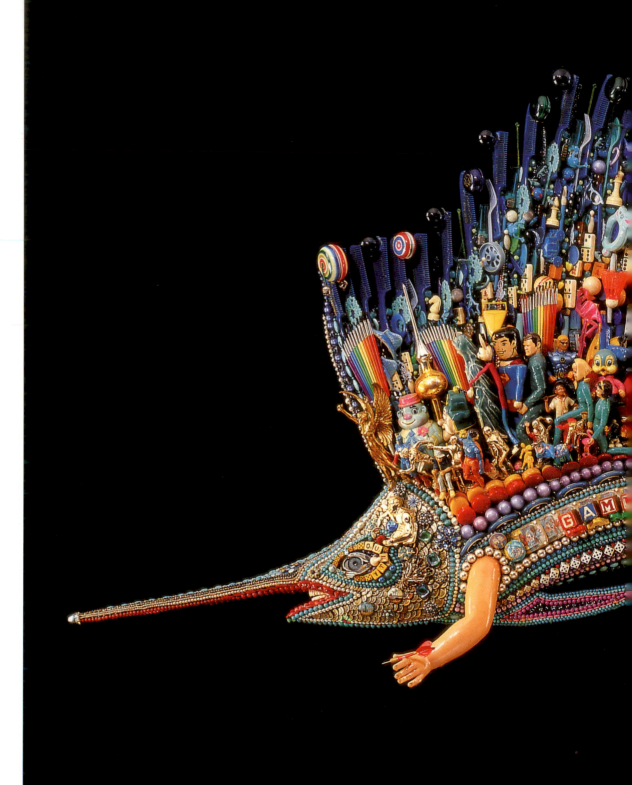

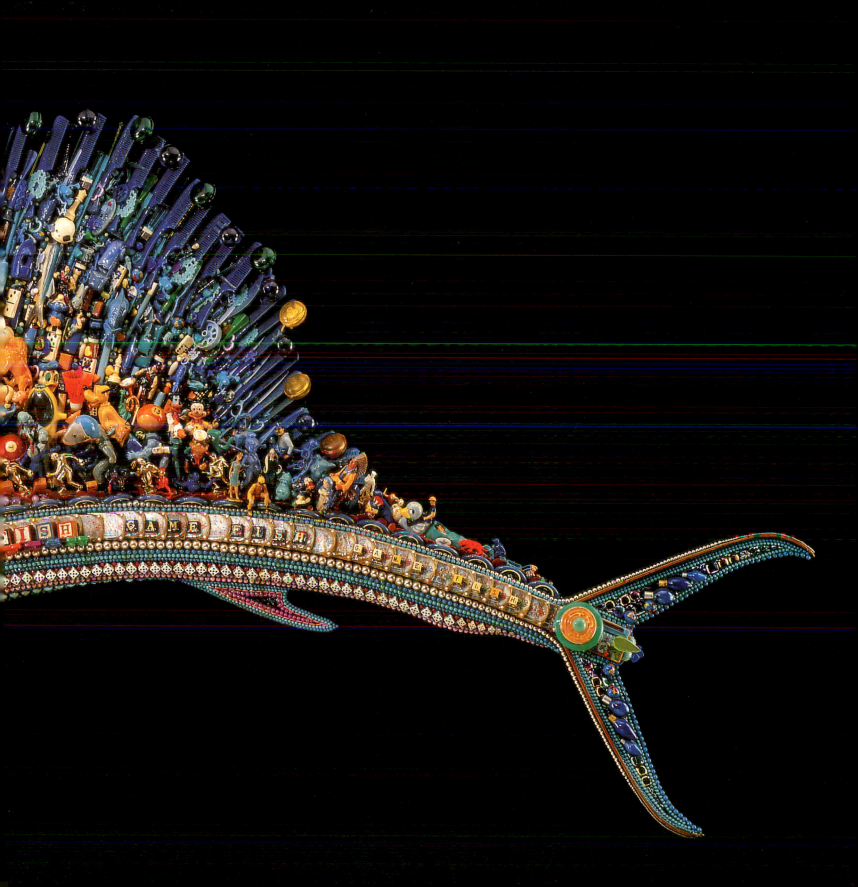

MYRA MIMLITSCH GRAY

born 1962

Sugar Bowl and Creamer III

1996, copper
creamer
10 ¾ x 10 x 4 in.;
sugar bowl
10 ¾ x 6 ¾ x 4 ½ in.
Smithsonian
American Art
Museum, Gift of the
James Renwick
Alliance on the
occasion of the
twenty-fifth
anniversary of the
Renwick Gallery

In her sugar bowl and creamer, Myra Mimlitsch Gray pays tribute to the classic designs of Colonial American silver. In a stroke of artistic wit and imagination, she turns the table, so to speak. Gray does not create an actual silver sugar bowl or creamer but gives us the image of the form in the same way that a fossil preserves a record of a life through time but not the life itself. That Gray focuses on domestic silver is no accident. Precious household objects help to remind us of the daily lives of women of earlier times. Gray's phantom sugar bowl and creamer are produced in copper, as though one metal were paying tribute to another.

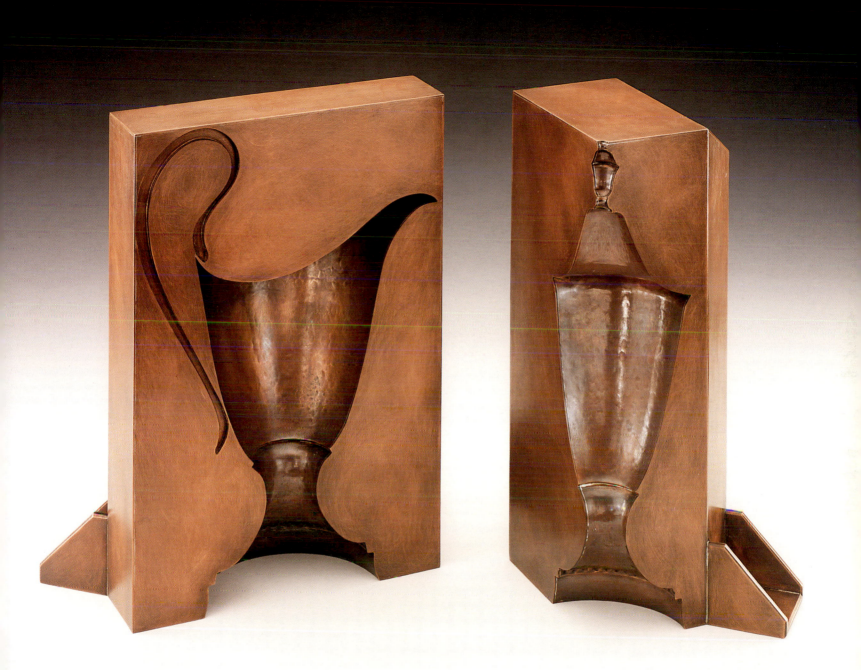

FRANÇOISE GROSSEN

born Switzerland 1943

Anatid

1981, natural
manila and gray
cotton rope
14 ½ x 93 x 19 in.
Smithsonian
American Art
Museum, Museum
purchase

The scientific name *Anatidae* refers to a large family of mostly aquatic birds that have relatively heavy bodies, short legs, webbed feet, and a bill with a horny nail at the tip and transverse, toothlike ridges on the biting edges. Included in this family are ducks, geese, and swans. The layered, heavy braids of Françoise Grossen's sculpture of natural manila and gray cotton rope suggest a large fowl at rest. The longer we study the sculpture, the less abstract and nonrepresentational it becomes.

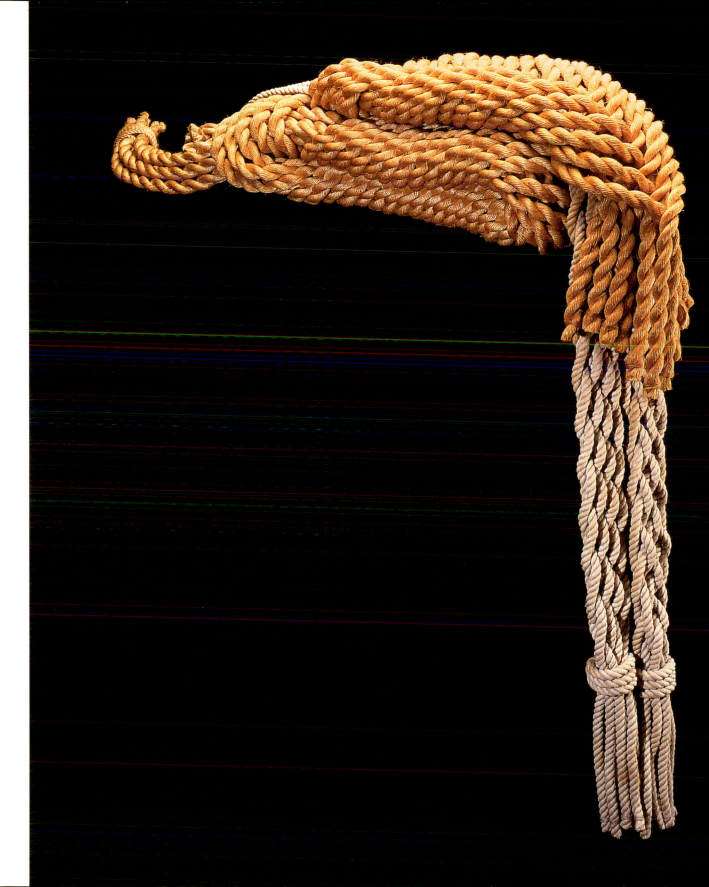

WILLIAM HARPER

born 1944

Self-Portrait of the Artist as a Haruspex

1990, gold, silver, enamel, pearl, coral, shell, and carapace
11 1/2 x 2 1/2 x 2 1/4 in.
Smithsonian American Art Museum, Gift of the James Renwick Alliance and musem purchase through the Smithsonian Institution Collections Acquisition Program

In ancient Rome a haruspex was a soothsayer who foretold events by reading the entrails of ritually slaughtered animals. Haruspices were revered and feared, for Romans believed that they had the power not only to divine the future but also to change it.

In *Self-Portrait of the Artist as a Haruspex* William Harper presents himself as both soothsayer and sacrificed animal. The piece is a metaphor for the creative process: the artist foretells his future by reading his own disemboweled intestines. At midsection on the body of the stick figure, we see the entrails atop the coral. The enameled circular head with drooping eyes and grimacing mouth expresses anguish. Harper's creativity is mystical and agonizing because it does not come without pain.

Harper's brooch is an opulent small sculpture meant to be contemplated more as an object in its own right than enjoyed as a piece of jewelry. The doll-like figure possesses a naiveté that betrays its sophistication. Harper incorporates an iridescent scarab carapace—a jewel of nature—in the forehead to symbolize the visionary power of the mind, a direct reference to the haruspex.

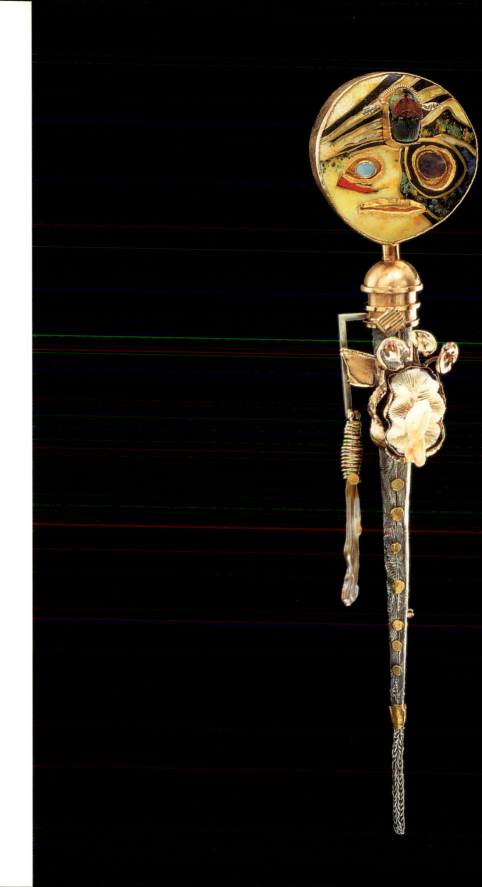

WAYNE HIGBY

born 1943

Temple's Gate Pass

1988, earthenware
14 x 33 x 8 in.
Smithsonian
American Art
Museum, Gift of
KPMG Peat Marwick

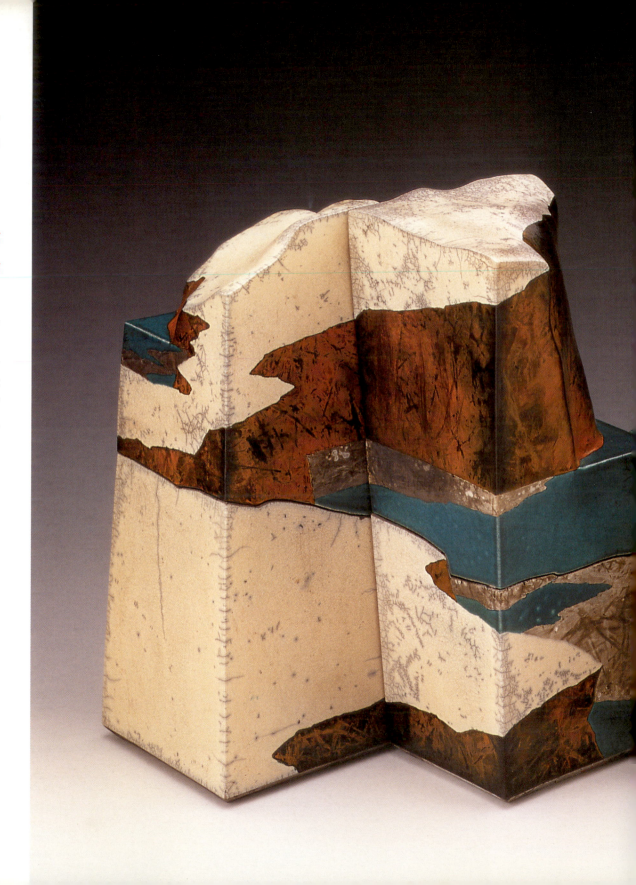

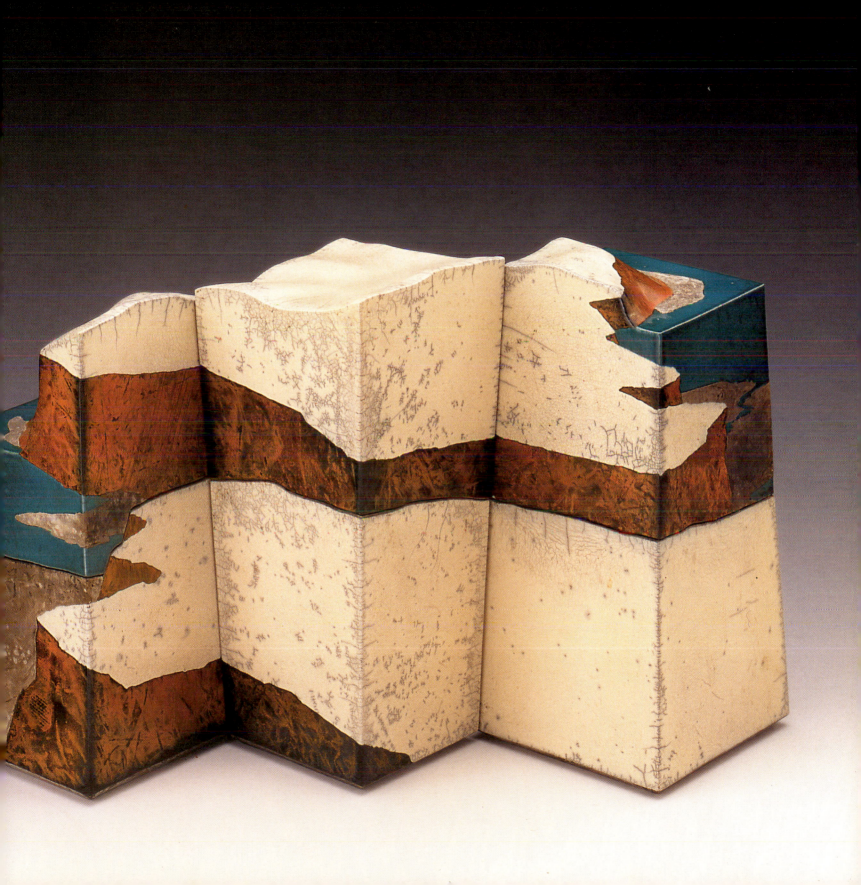

ERIC HILTON

born England 1937

Storm

1996, crystal
and granite
9 ½ x 8 x 8 in.
Smithsonian
American Art
Museum, Gift of the
James Renwick
Alliance on the
occasion of the
twenty-fifth
anniversary of the
Renwick Gallery

Deep within this intimate sculpture of clear glass, an intense storm appears to be blowing across an unknown landscape. Is this a phenomenon brewing in interstellar space, a disturbance churning the ocean floor, or a tempest howling across a polar cap? We will never know. The cold, pristine glass, suggestive of a block of perfect ice, reinforces the sense of a hostile environment. Hilton is aware that phenomena in outer space, such as violent storms on the sun, affect our planet. *Storm* is the artist's invitation to contemplate the great mystery of our place in the universe. In his small sculpture Hilton captures a sense of the cosmos in constant expansion, frozen in time in pure glass.

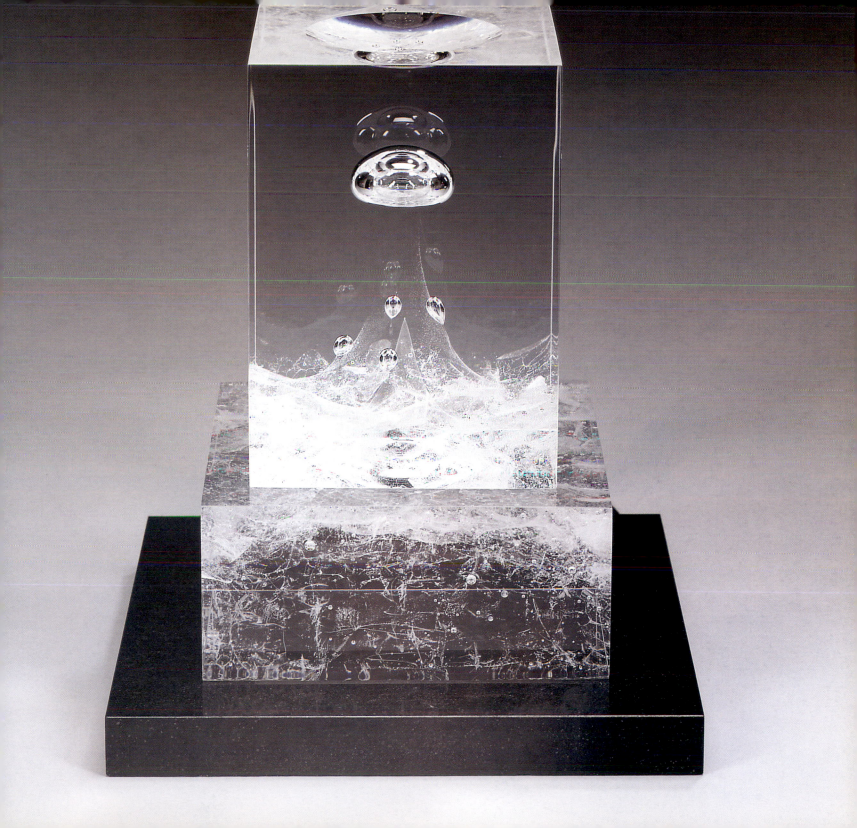

MICHELLE HOLZAPFEL

born 1951

Bound Vase

1989, cherry burl
15 x 12 ½ in.
Smithsonian
American Art
Museum, Gift of
Jane and Arthur K.
Mason on the
occasion of the
twenty-fifth
anniversary of the
Renwick Gallery

Michelle Holzapfel is one of the few women to have achieved success in the male-dominated field of wood turning. She thinks of herself as a sculptor who uses wood and the lathe to transcend the medium to attain artistic goals. Formally, *Bound Vase* is a sculpture that exalts the beauty of cherry burl in soft curves and the illusion of cloth. However, we are never fooled. The vase can hold nothing, and we are aware that the "cloth" is carved wood.

Although Holzapfel prefers not to present herself as a feminist artist in large part because of the perhaps limiting connotation of the term, her art often refers to the domestic lives of women. The basic components of *Bound Vase* are a vase and a cloth wrap, implying that in our culture beauty and ornamentation are often associated with women.

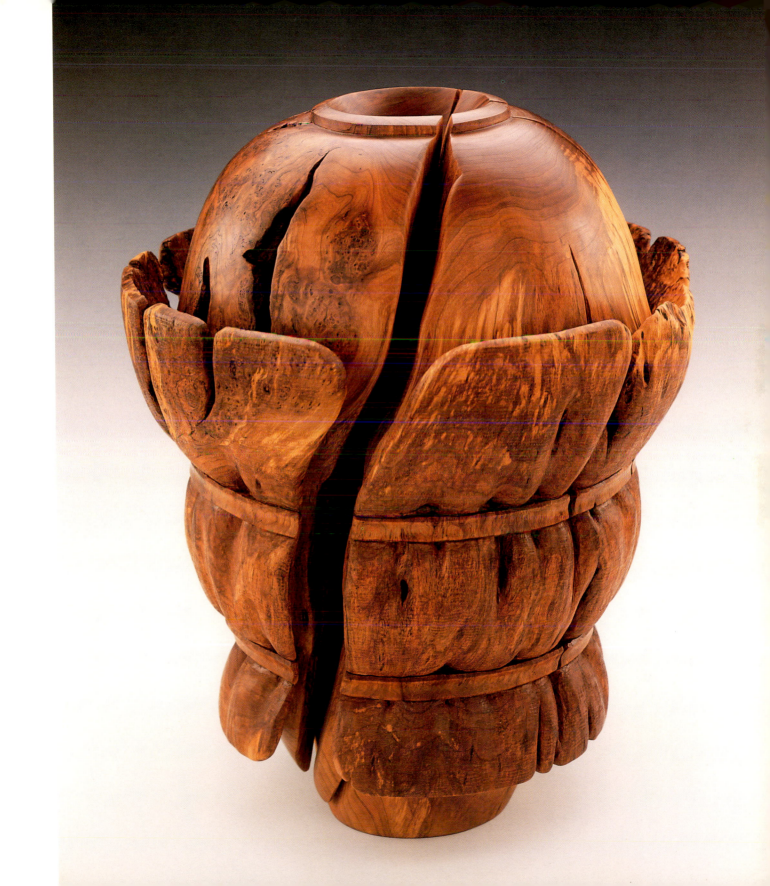

MARY LEE HU

born 1943

Choker (#38)

1978, silver, gold,
and copper
9 5/8 x 6 1/2 x 7/8 in.
Smithsonian
American Art
Museum, Gift of the
James Renwick
Alliance

Mary Lee Hu weaves, wraps, loops, and twines silver and gold wire to create one-of-a-kind jewelry of extraordinary beauty. Her designs are symmetrical, precisely ordered, and delicate. Hu makes jewelry to be worn because she believes it is most alive when in contact with the human body. For inspiration for her designs she often goes directly to nature or searches through books on natural history. Small sea creatures, veins in leaves, ferns, plant tendrils, and microscopic organisms make up a small part of her design vocabulary. In its lacy delicacy, *Choker* evokes shell forms, plant growth, curling fronds, and featherlike fins.

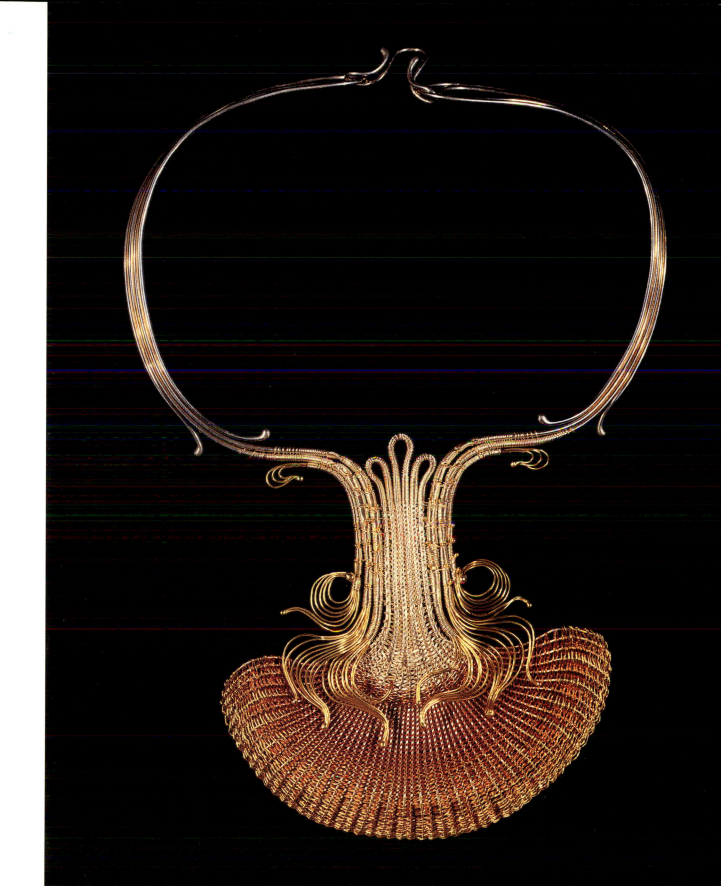

WILLIAM HUNTER

born 1947

Cuzco Moon

1987, vera wood
14 ¼ x 14 ½ in.
Smithsonian
American Art
Museum, Gift of
Jane and Arthur K.
Mason on the
occasion of the
twenty-fifth
anniversary of the
Renwick Gallery

William Hunter often chooses exotic woods for his turned vessels and sculptures. For example, *Cuzco Moon* is turned from vera wood, an evergreen native to Colombia and Venezuela. The prominent blond mark in the wood inspired the title. A city in southern Peru, Cuzco was the capital of the Incan empire from the eleventh century to the Spanish conquest in the early sixteenth century. The Incans worshiped the Sun god, Inti, and his wife, the moon goddess, Mama Quilla, who oversaw marriages and feast days.

One of the most accomplished artists in the contemporary wood-turning movement in the United States, Hunter has adopted swirls and spirals as his signature. *Cuzco Moon* is a large ovoid vessel dominated by a patch of light wood surrounded by darker wood. His carved linear elements follow and reinforce the pattern of the wood grain to maximum effect. Contrasting sharply with the pale moon on the side is the circular opening that appears almost black. The vase is alive with movement, a never-ending visual delight.

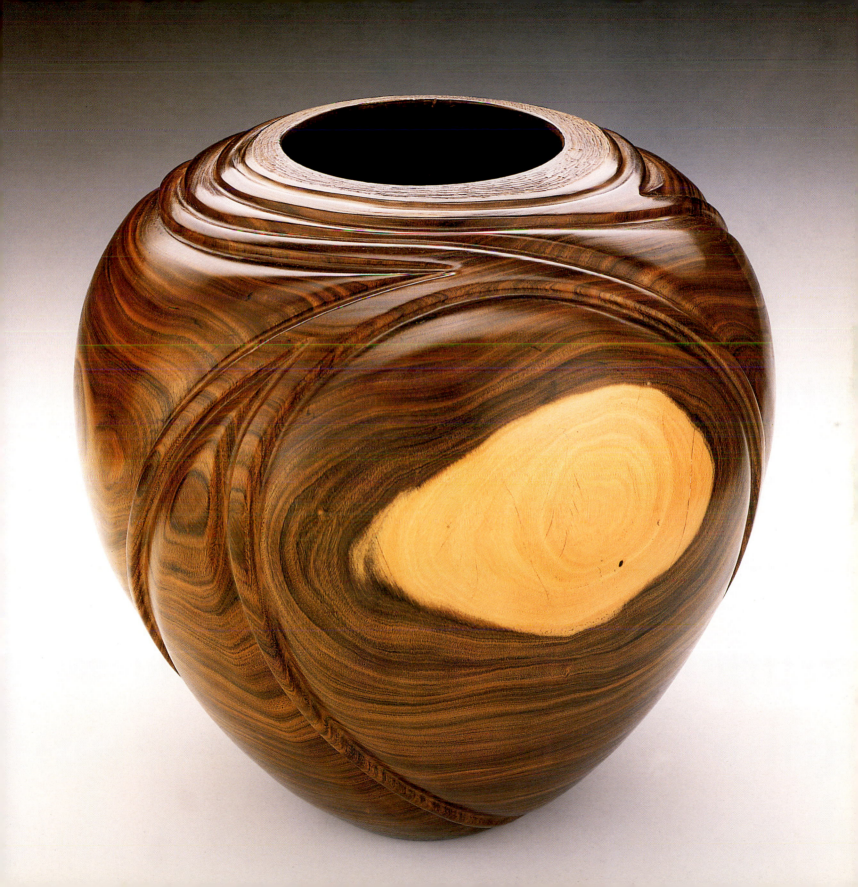

MICHAEL HURWITZ

born 1955

Rocking Chaise

1989, mahogany,
steel, and paint
36 x 90 x 24 in.
Smithsonian
American Art
Museum, Gift of
Anne and Ronald
Abramson,
the James Renwick
Alliance, and
museum purchase
through the
Smithsonian
Institution
Collections
Acquisition Program

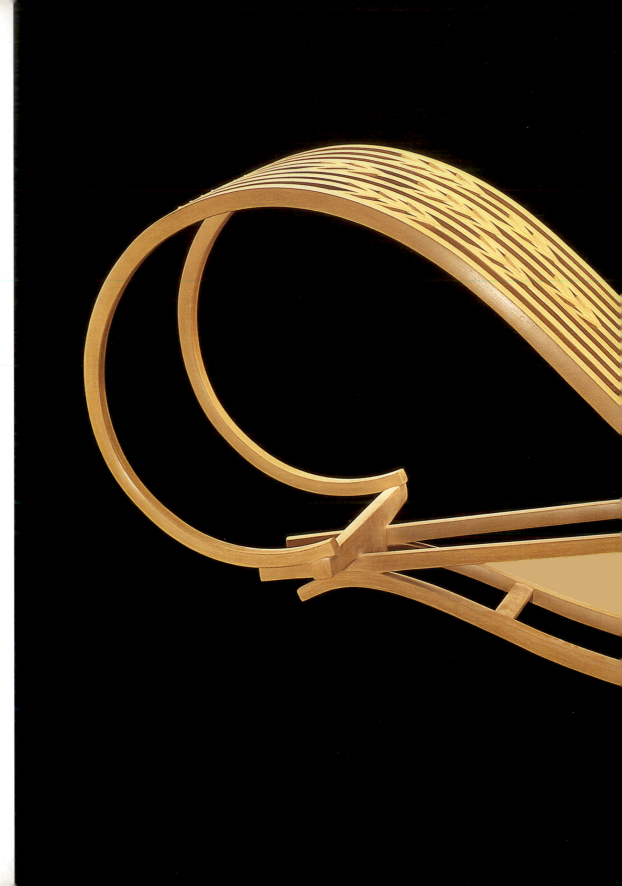

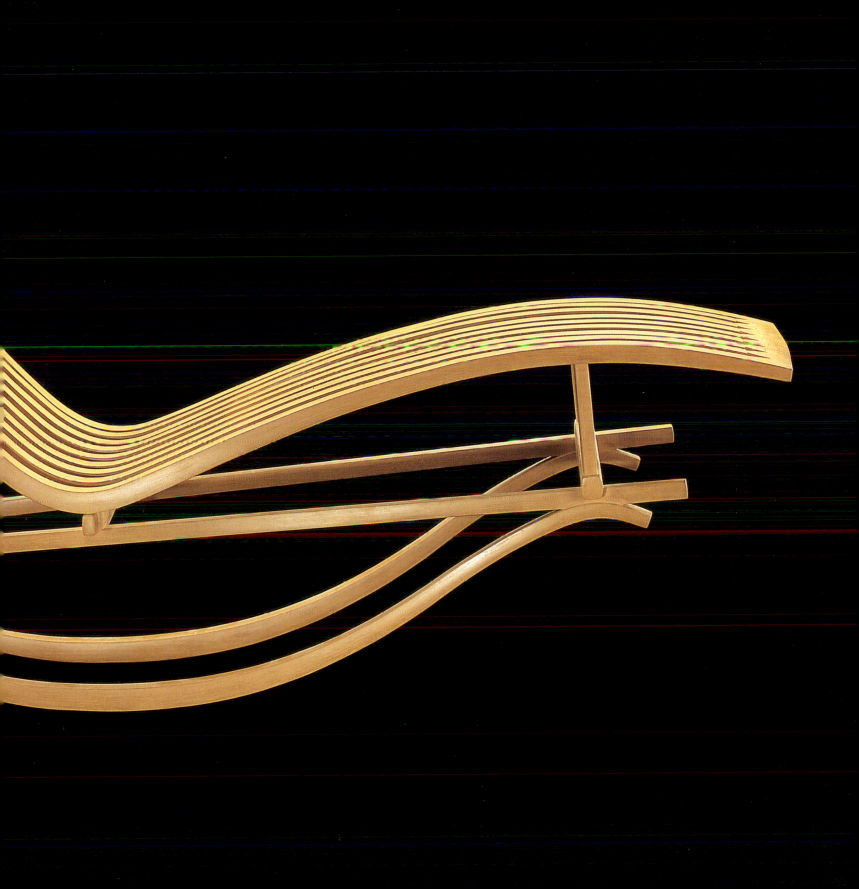

MARY A. JACKSON

born 1945

Low Basket with Handle

1999, sweetgrass, pine needles, and palmetto
16 x 17 in.
Smithsonian American Art Museum, Gift of Marcia and Alan Docter

Born in Mt. Pleasant, near Charleston, Mary Jackson is steeped in the Gullah traditions of South Carolina's Sea Islands. Although her baskets are indebted to the traditions of sweetgrass basket making of her West African forebears, she commonly varies historical designs or adds new patterns to her repertoire.

Jackson sews her coiled baskets from the most humble of materials gathered in the wild: sweetgrass, palmetto, long-leaf pine needles, and bullrush. Jackson's forms are clean, simple, and restrained, and her decorative designs enhance each piece. The beauty of this low basket lies in its play of circles. The circular basket form with its wide opening is reiterated in the exaggerated upright handle. Much like an engineer, Jackson understands the nature of her materials and how they will react under different conditions. For example, the handle attaches to the basket in such a way that it has a springlike drop when picked up or filled.

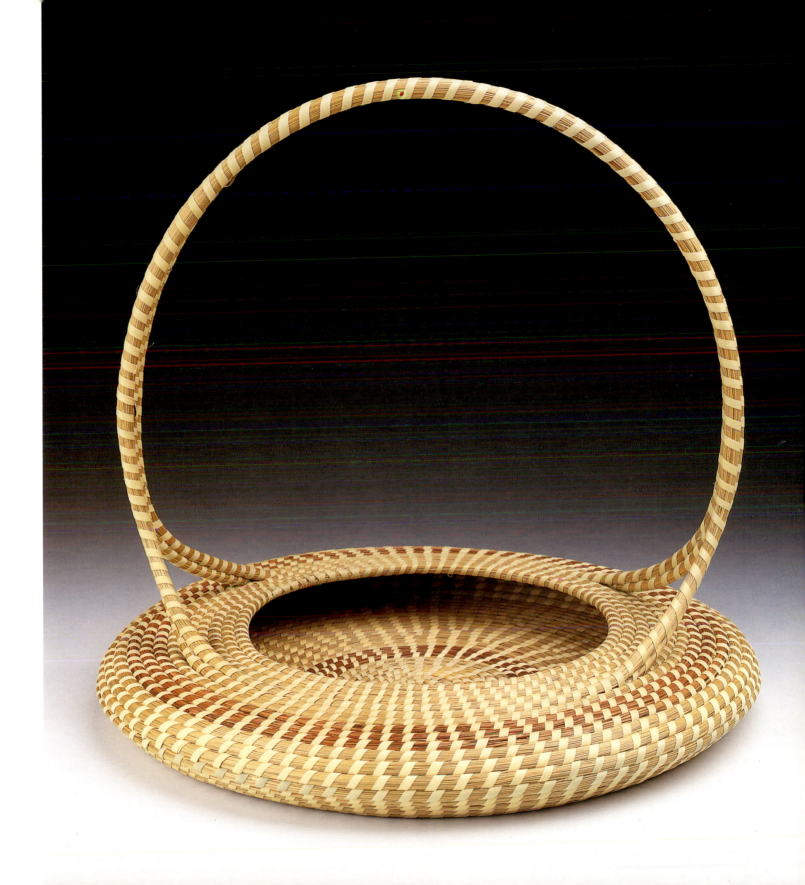

MICHAEL JAMES

born 1949

Quilt #150: Rehoboth Meander

1993, cotton
and silk
53 x 52 ½ in.
Smithsonian
American Art
Museum, Gift of the
James Renwick
Alliance

Quilt #150: Rehoboth Meander is typical of the mature art quilts that Michael James has created since the early 1990s. The title refers to a small town in Massachusetts where the artist lived. James has replaced the rigid rectangular grid of most traditional quilts with diagonal lines. Like a composer weaving together musical motifs in a concerto, he constructed *Rehoboth Meande*r from hundreds of strips of commercial cotton and silk fabrics, ranging in color from dark hues to soft pastels to iridescent effects. Each strip, equal in width, suggests a brush stroke applied to canvas.

The quilt pulsates with energy, a dynamic visual impression produced by the parallel diagonal lines and complicated interplay of colors. Four ideogrammatic designs appear to float across the quilt, creating tension between the bold patterns and the crisp diagonals that give the illusion of depth.

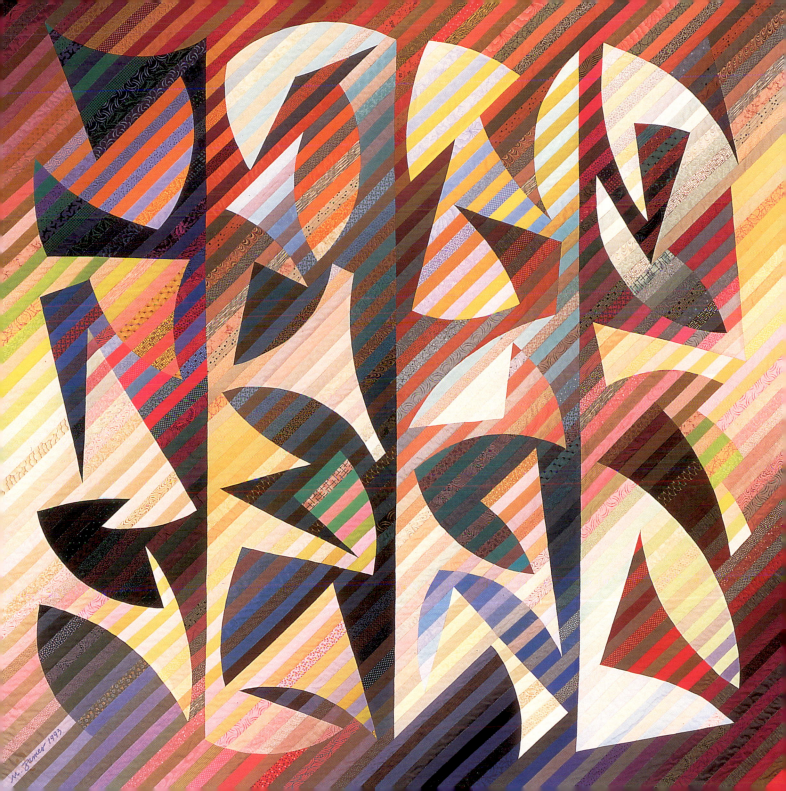

SAM MALOOF

born 1916

Rocker

1980, walnut
44 ¾ x 45 ¾ x 26 ¾ in.
Smithsonian
American Art
Museum, Gift of
Roger and Frances
Kennedy

Furniture designer and maker Sam Maloof is one of the few artists in the contemporary studio craft movement to have achieved celebrity. Still active in his late eighties, he has made and designed furniture for more than fifty years. Often referred to as a first-generation studio furniture maker (those born before World War II), Maloof has determinedly stayed his course, succumbing neither to fad nor fashion. He is best known for his custom-designed chairs and rockers. Ironically, Maloof is most identified with his rocking chairs at a time when the rocker is not commonly found in many American homes. His rocking chairs are at once functional pieces and lively sculptures. Owning a Maloof rocker carries cachet. This rocker embodies the hallmarks of Maloof's mature furniture. The individual components—back, seat, arms, legs, and rocker blades—are integrated into a visually satisfying design. The chair is complete from every angle in the same way that a successful sculpture exists in space. The beauty of the wood enhances the rocker's clean lines and exuberant design.

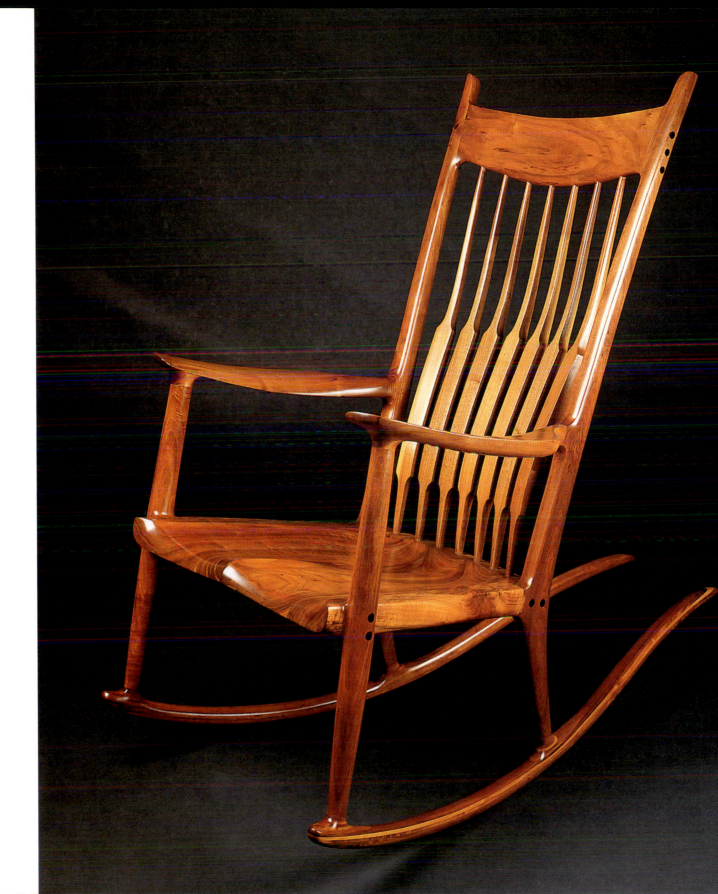

DANTE MARIONI

born 1964

Red Group

1995, red and
black glass
28 ⅛ x 10 ½ x 6 in.;
33 ½ x 7 x 6 ⅜ in.;
and 14 x 13 ¼ x 9 in.
Smithsonian
American Art
Museum, Gift of the
James Renwick
Alliance

Red Group comprises three classically inspired vessels that Dante Marioni arranged to relate to one another. The interplay of volume, silhouette, and color creates exciting spatial relationships. Many of his sculptures consist of three vessels. To distinguish the trios from each other, he employs different color schemes—yellow with black, purple with orange, and black with white. Although it might seem that Marioni's primary interest is color, his sculpture succeeds because he pays equal attention to form. These large, attenuated shapes are full of life and dynamically complement each other.

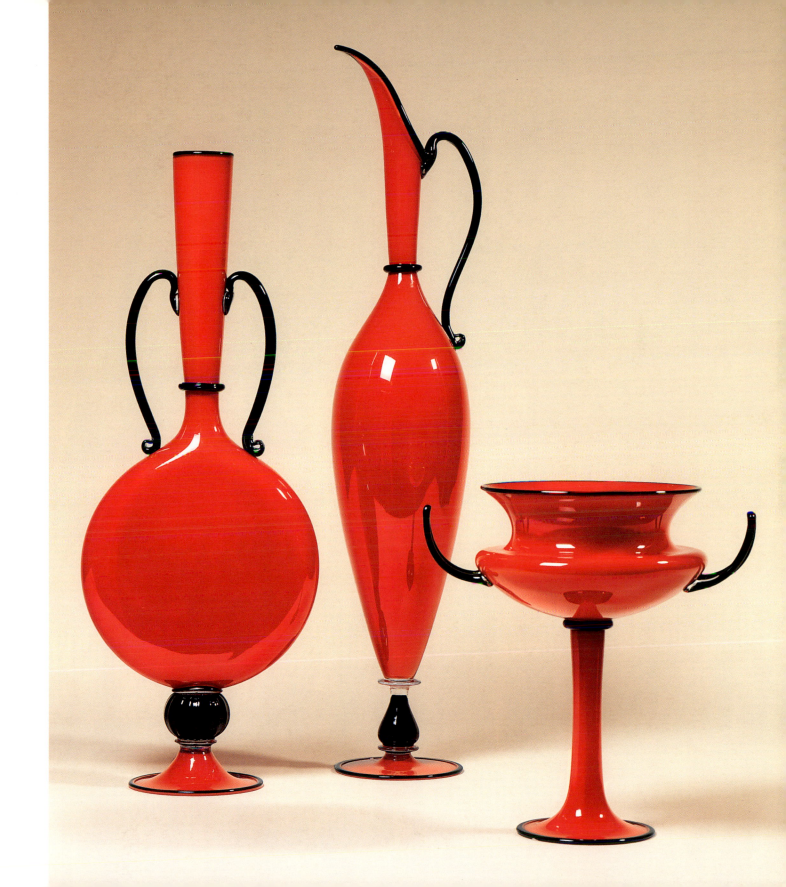

RICHARD MARQUIS

born 1945

Teapot Goblets

1991, 1992, and
1994, clear and
colored glass
(left to right):
7 ¾ x 5 x 5 in.;
10 ¼ x 4 x 3 ⅝ in.;
10 ½ x 4 ½ x 3 ½ in.;
11 x 3 ⅝ x 3 ⅝ in.;
and 7 ⅝ x 5 ¾ x 5 ¾ in.
Smithsonian
American Art
Museum, Gift of the
James Renwick
Alliance

These five teapot goblets were never intended to be used. They are instead objects that refer directly to the history of glass. Put simply, they are glass about glass. Richard Marquis has blown these goofy forms using a technique called *zanfirico* ("twisted glass") in which glass canes, or rods, are used to create geometric patterns and interlacing swirls. Although these fanciful pieces combine goblets and teapots into single objects, there is no such thing as a teapot goblet in the history of the decorative arts. The artist is fascinated with color and with using traditional forms nontraditionally.

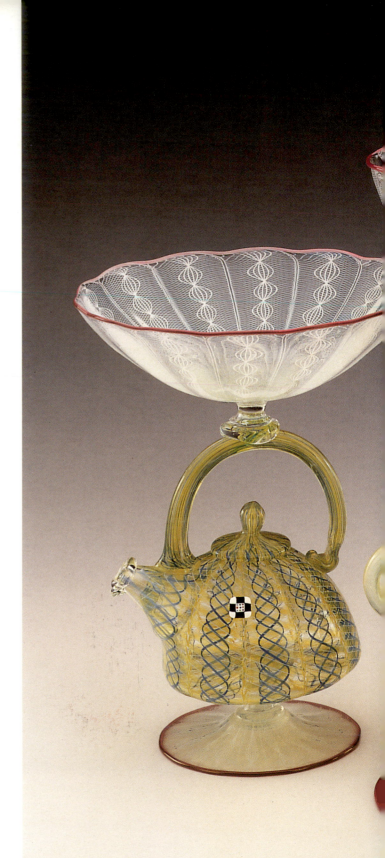

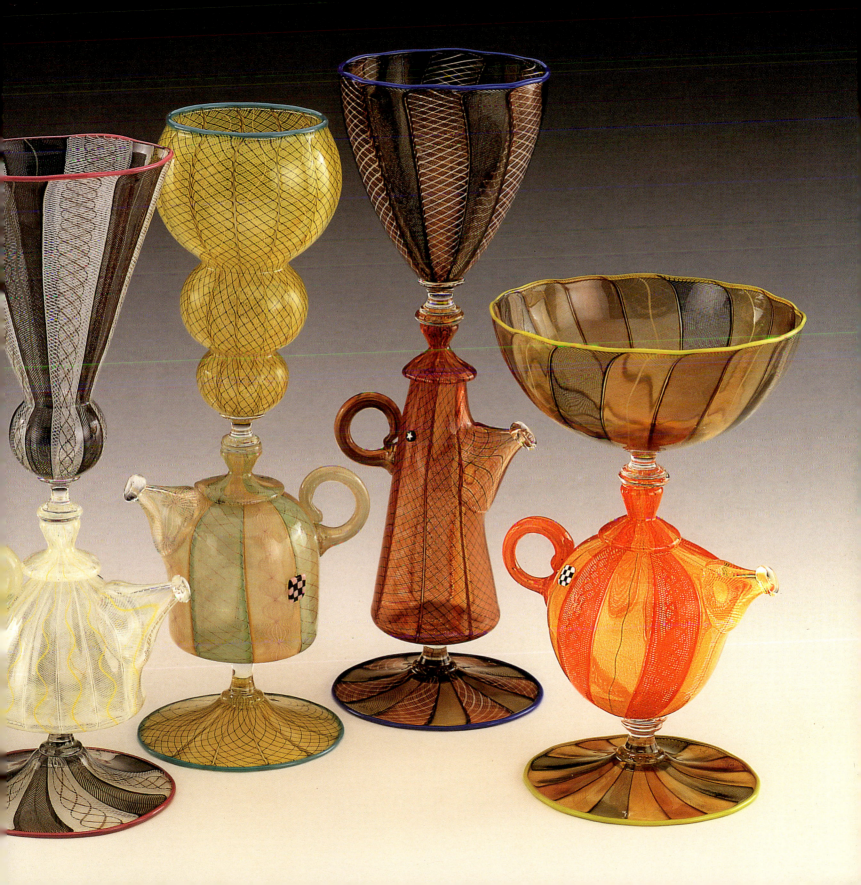

RICHARD MAWDSLEY

born 1945

Feast Bracelet

1974, silver, jade, and pearls

3 ¾ x 2 ¾ x 4 ½ in.

Smithsonian American Art Museum, Gift of the James Renwick Alliance in honor of Lloyd E. Herman, Director Emeritus, Renwick Gallery

In its exacting craftsmanship and intricate details, Richard Mawdsley's sterling silver *Feast Bracelet* brings to mind masterworks by Renaissance goldsmiths, the opulence of seventeenth-century Dutch still lifes, and photographically realistic paintings of the 1970s. These sources of inspiration emphasize a virtuosity in art making that assumed the power of magic.

The bracelet depicts a sumptuous banquet in exquisite detail. In a pileup of miniature forms we see various fruits and vegetables, together with serving cup, compote, pie dish, plate, cloths, table scarves, and a wine bottle in a wine cooler. Completing the array of items are jade spheres as lamp globes flanking the table. *Feast Bracelet* is the ultimate conversation piece. Although the bracelet can be worn, it is too large to be worn for long. Mawdsley's sculpture is a tour de force that is meant to be contemplated. It is its own reward for being.

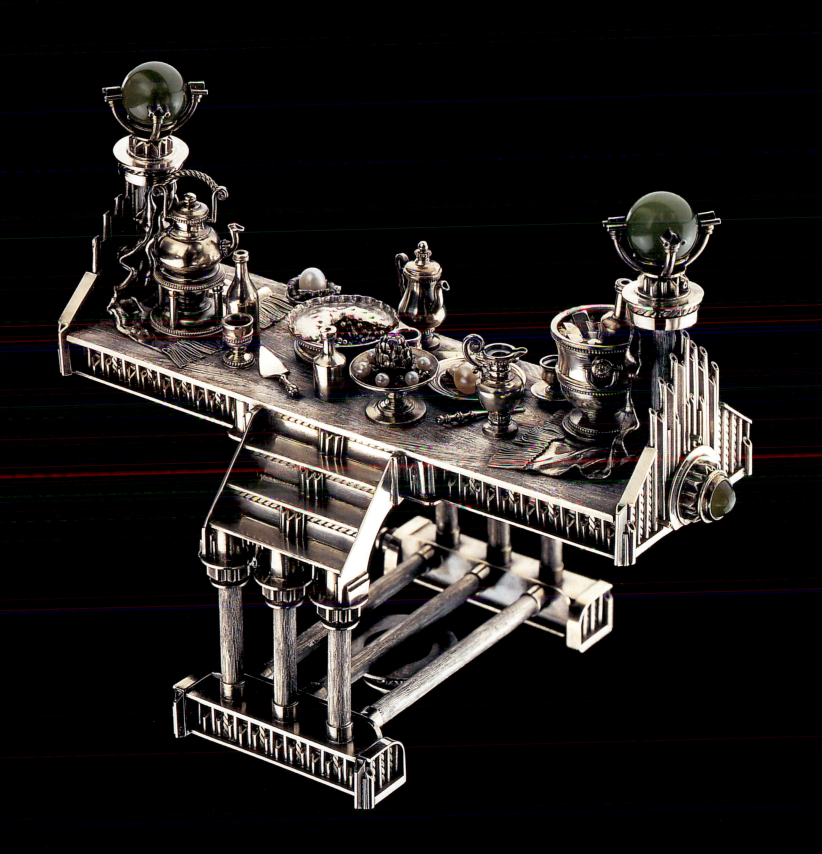

JUDY KENSLEY McKIE

born 1944

Monkey Settee

1995, walnut
and bronze
35 ½ x 71 ¾ x 24 in.
Smithsonian
American Art
Museum, Gift of the
James Renwick
Alliance in honor of
Michael W. Monroe,
Renwick Gallery
Curator-in-Charge,
1986–95

Unlike the traditional settee, Judy McKie's *Monkey Settee* has no continuous back, is curved, and has four arms instead of two. *Monkey Settee* is really two chairs with arms and back conjoined by a table in the middle, suggesting a stately double throne. The rigid formal design of the piece and the use of stylized monkeys as guardian-like arms are reminiscent of furniture in royal courts in West Africa. We might imagine the monkeys of this "monkey throne" to be symbols of powerful African families just as the peacock and the chrysanthemum were emblems of ancient Persian and Japanese thrones. McKie's witty monkeys embody the character of these playful animals. Decorative and streamlined, they bring to mind Moderne designs of the 1930s and 1940s.

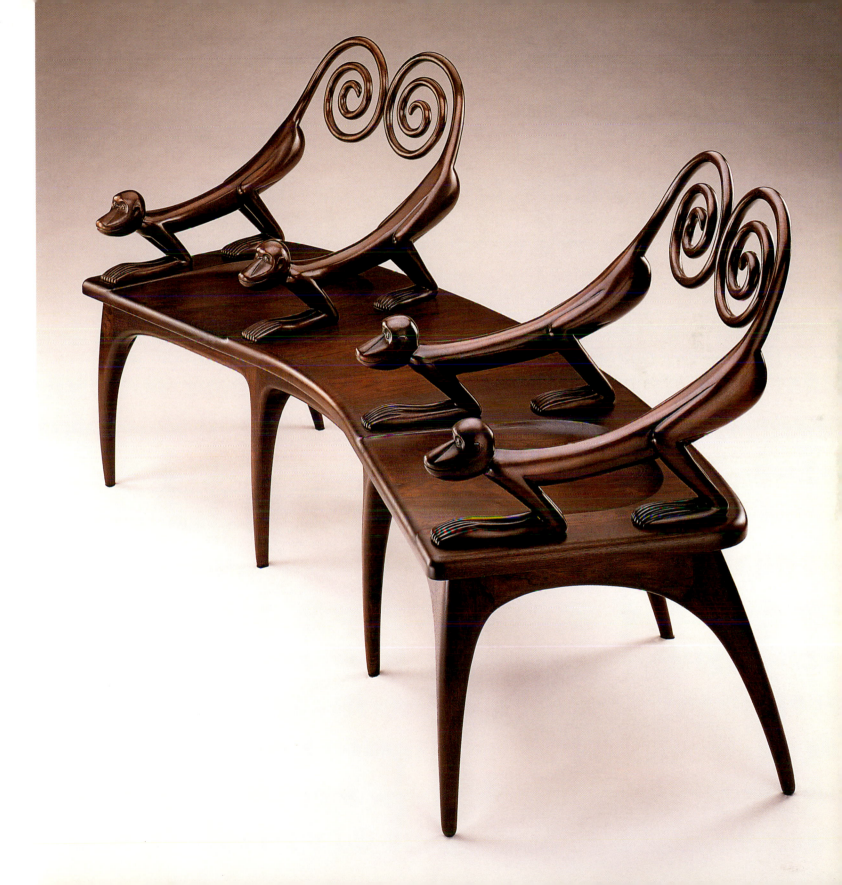

JOHN McQUEEN

born 1943

Untitled #192

1989, burdock burrs
and applewood
22 ¼ x 18 x 20 ¾ in.
Smithsonian
American Art
Museum, Gift of the
James Renwick
Alliance

John McQueen's baskets and containers are sophisticated rearrangements of natural forms. *Untitled #192* is a massive basketlike piece composed of burrs—prickly seed carriers from plants that stick to clothing or animal fur—and applewood twigs to suggest something not so much deliberately created but found by chance. In fact, the work seems so natural that it is hard to think of it as made by a human being.

McQueen is fascinated by the organic, free-form qualities of trees and other plants. Speaking of one object, he said, "There's no designing, just selection. It's nature. The tree has really made the piece." McQueen's gift as an artist is to reveal the uncommon in what we take for granted.

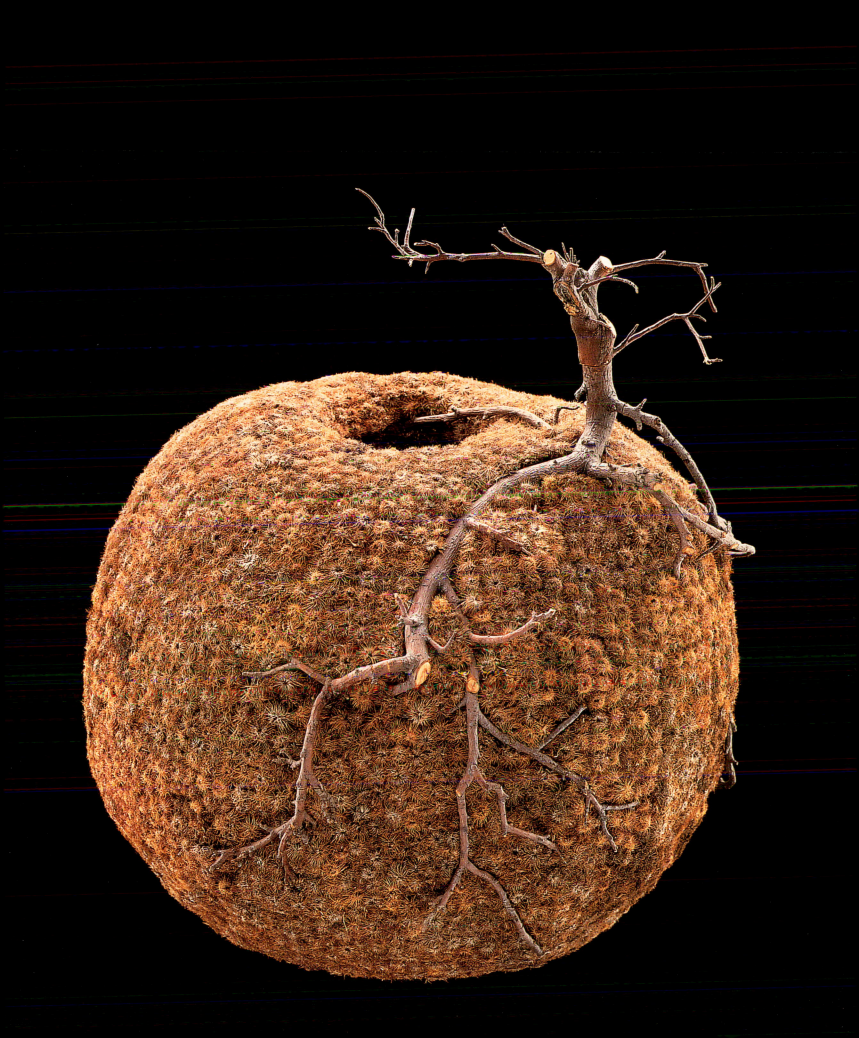

GEORGE NAKASHIMA

1905–1990

Conoid Bench

1977, walnut
and hickory
31 1/8 x 34 1/2
x 35 5/8 in.
Smithsonian
American Art
Museum, Gift of
Dr. and Mrs.
Warren D. Brill

Conoid Bench is one of George Nakashima's signature furniture forms. He took the word "Conoid" from the name of his studio in New Hope, Pennsylvania, which had a conical roof. Nakashima designed simple, elegant furniture that was meant to be used. Often his pieces were based on the principle that form should follow the grain of the wood. Whereas most people see crevices and cracks to be defects, Nakashima saw such imperfections as beautiful. The bench seems to exist in an uneasy space between furniture that is rustic and furniture refined over centuries. To the initiated, however, Nakashima's one-of-a-kind piece is sophisticated in its rusticity.

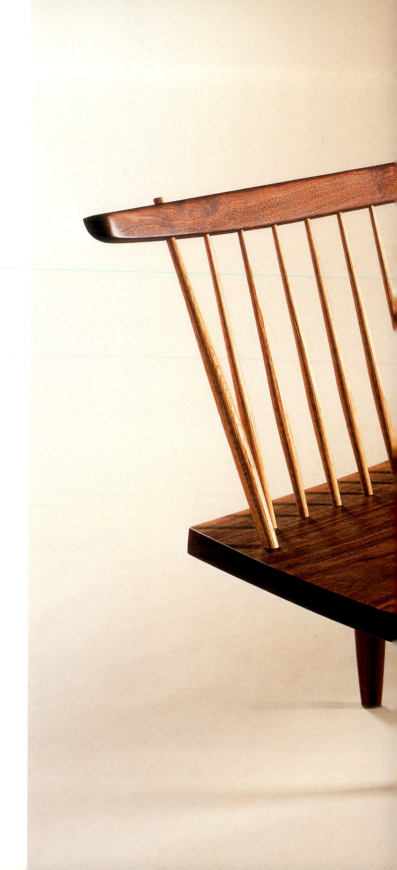

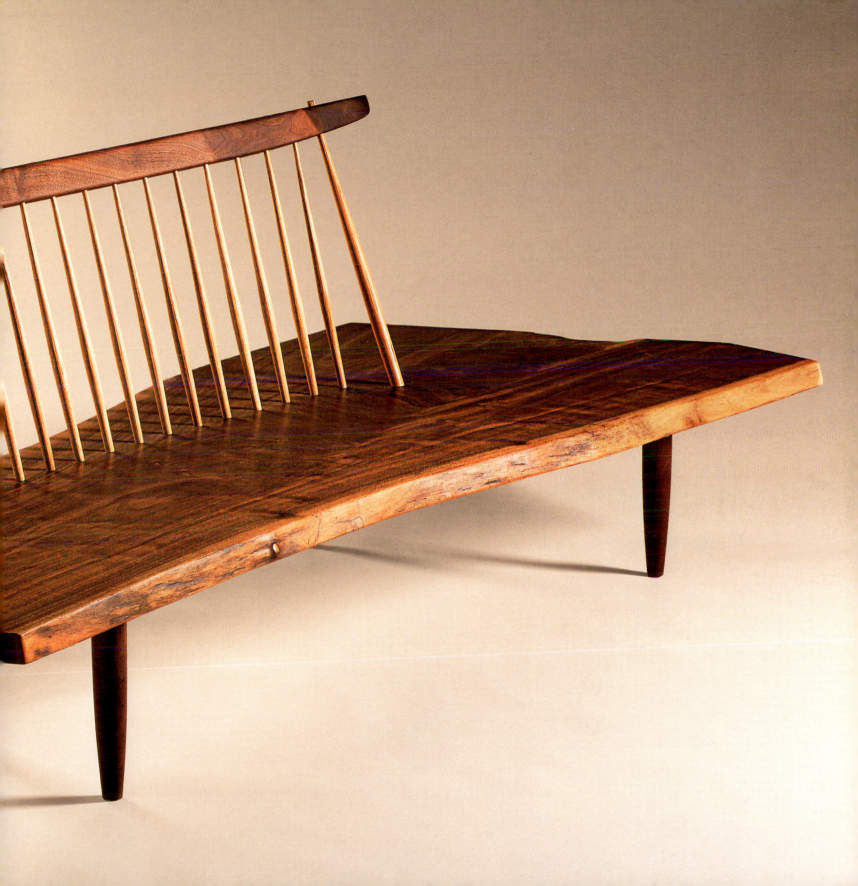

ALBERT PALEY

born 1944

Pendant

1973, gold, silver, copper, labradorite, moonstone, jade, glass, ivory
22 x 8 ½ x 1½ in.
Smithsonian American Art Museum, Gift of the James Renwick Alliance and museum purchase through the Smithsonian Institution Collections Acquisition Program

Before he became known for his massive, writhing iron furniture and architectural commissions, Albert Paley created groundbreaking jewelry that redefined the concept of body ornamentation in the mid-twentieth century. This pendant is a masterpiece of his wearable sculpture. Its sumptuous materials, complexity of design, and sheer commanding presence remind one of tribal talismans, powerful objects believed to attract good fortune as they ward off evil.

In designing his jewelry, Paley had a definite type of woman in mind. "My jewelry was meant to be worn by women who had the psychological and political bearing to deal with their sexuality and self-image," he said. The pendant was not designed to be worn by the faint of heart or the self-conscious. It demands that the wearer possess confidence and charisma.

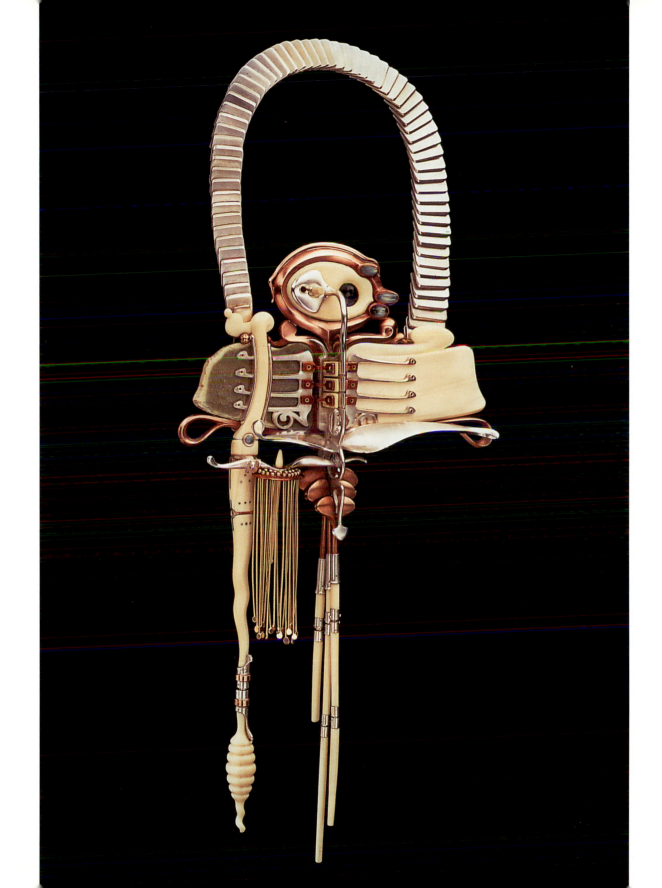

YVONNE PORCELLA

born 1936

Takoage

1980, cotton
and polyester
82 ½ x 71 ½ in.
Smithsonian
American Art
Museum, Museum
purchase through
the Smithsonian
Institution
Collections
Acquisition Program

The title of Yvonne Porcella's first art quilt is *Takoage*, a Japanese word that means "kite flying" and refers to the traditional kite festival on New Year's Day in Japan. In an unorthodox move, which she justified as appropriate for an "art quilt," Porcella stitched along the printed kite strings of the back fabric. Before 1986, Porcella focused primarily on color, which she chose intuitively for its psychological and emotive power. Often using red, her favorite color, she adds other colors to create vibrant harmonies. There is nothing subtle about a Porcella quilt. Her trademark style is an irregular grid of dazzling hues relieved by half-squares of black and white to give the eye a rest. Porcella's quilts are musical and theatrical.

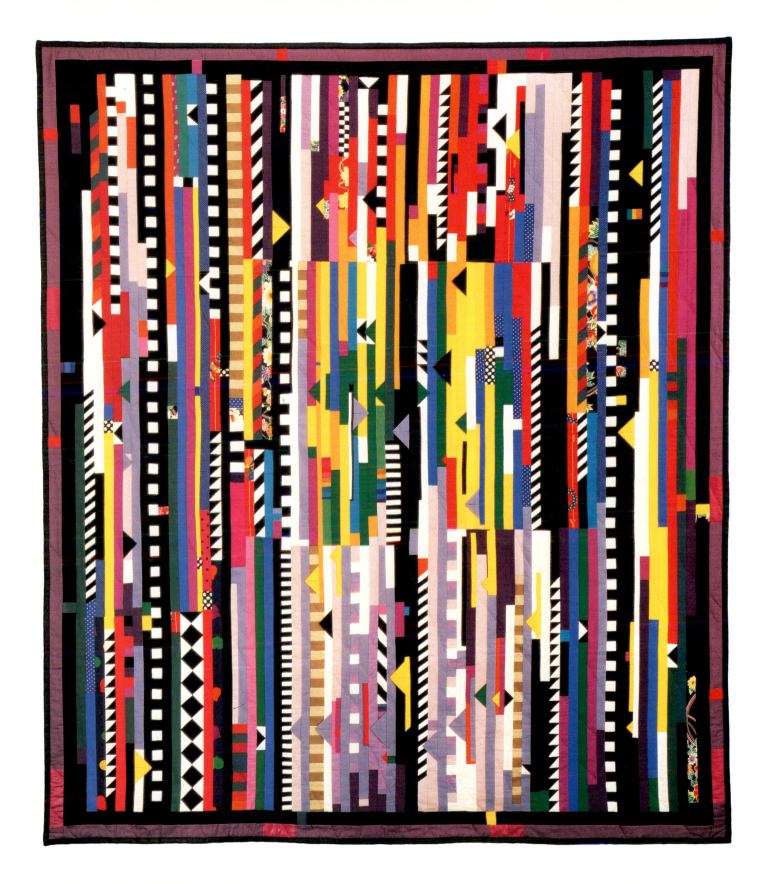

JAMES PRESTINI

1908–1993

Bowls

1933–53
Mexican mahogany
4 ¾ x 9 in.; and
7 ⅜ x 13 ½ in.
Smithsonian
American Art
Museum, Gift of the
artist

Often called the father of the lathe-turned wood movement in America, James Prestini began to turn wood bowls and plates in the 1930s. Because his forms are deceptive in their simplicity and devoid of decoration, it is easy to dismiss them as handicraft imitating machine production. Prestini's pieces, however, are amazingly thin and have retained their integrity, despite the propensity of wood to split or warp as climatic conditions change. His genius lies in his choice of woods and his alignment of grains to create subtle decorative effects. Ultimately, however, Prestini's artistry is revealed in his integration of lathe skill, knowledge of woods, and sensitivity to form and finish.

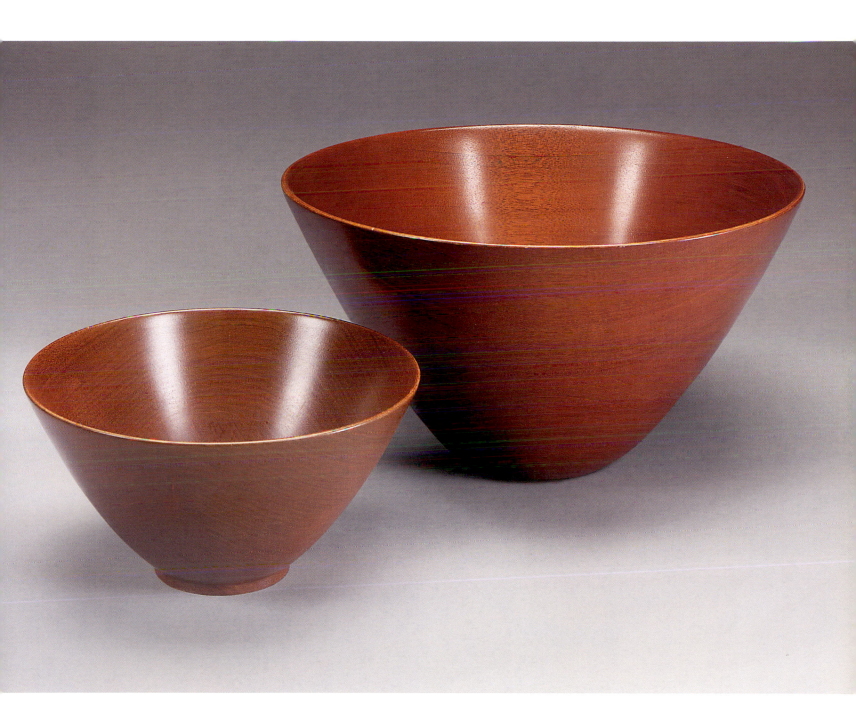

KEN PRICE

born 1935

Blue Pearl

1996, earthenware
with acrylic paint
19 x 21 x 15 in.
Smithsonian
American Art
Museum, Gift of the
James Renwick
Alliance

Ken Price modeled *Blue Pearl* in clay and then painted it with acrylic
to imitate glaze, thus consciously blurring the historically antithetical
aesthetic categories of craft and fine art. The soft undulating contours
and the bluish-purple iridescent finish may suggest that the sculpture
was inspired by the fabled giant Tahitian pearl, one of the most prized
pearls of all. The work can also be read as a geological formation. The
rugged landscape of northern New Mexico, where Price spends part of
each year, inspired the eroded forms of the sculpture. In addition, the
correspondence of *Blue Pearl* to the human body cannot be ignored.
The rounded forms suggest human curves, and the enigmatic opening,
bodily orifices.

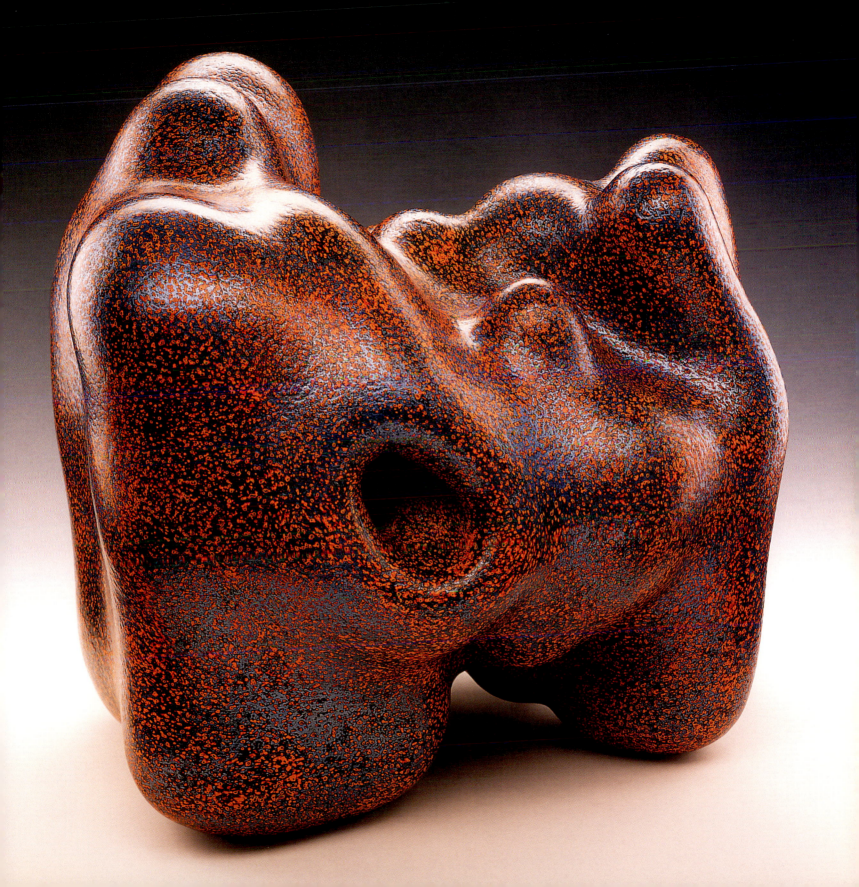

JOHN PRIP

born 1922

Coffeepot

1958, silver
and ebony
11 ¾ x 9 ¼ x 4 ½ in.
Smithsonian
American Art
Museum, Gift of the
James Renwick
Alliance and
museum purchase
through the
Smithsonian
Institution
Collections
Acquisition Program

John Prip created this elegant coffeepot—more correctly a coffee server—to grace a formal table set for breakfast or dinner. The use of precious metal and superbly crafted design set the work apart from mass-produced coffeemakers and servers available to millions of consumers. Made in silver with ebony finial and handle, the piece is a perfect example of the twentieth-century design dictum: form follows function. The erect, attenuated spout pours effortlessly without dripping, the finial is tall enough to be grasped easily, and the exaggerated elbow handle offers ample space for the hand.

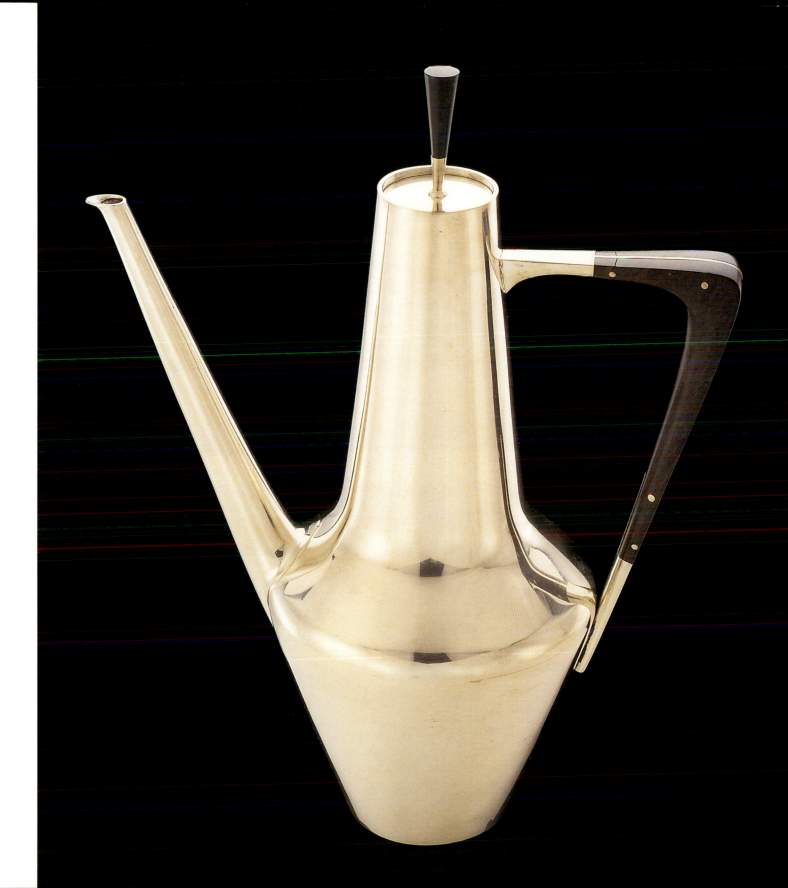

KENT RAIBLE

born 1955

Floating City

1996, gold, chrome, diamonds, sapphires, amethysts, chalcedony, and tourmaline
10 ¼ x 5 ⅜ x 1 in.
Smithsonian American Art Museum, Gift of the James Renwick Alliance

Kent Raible is an independent jewelry designer and maker who creates one-of-a-kind high-style jewelry in the grand tradition of Cartier and Tiffany. Raible does not use his jewelry for social or political comment, nor does he use disparate materials as an anti-aesthetic or for special effect. Made mostly of gold and precious and semiprecious gemstones prized for their brilliant color and translucency, Raible's work suggests a court tradition of jewelry that flourished when royal families patronized particular jewelry makers.

When Raible conceived *Floating City,* he had in mind the lost city of Atlantis, a mythical island that fires the human longing for utopian places. To envision Atlantis, Raible studied such film classics as *The Wizard of Oz* and *Close Encounters of the Third Kind.*

Floating City is a fantasy. The pendant, which resembles a spaceship in a science-fiction film, presents a futuristic metropolis in miniature. The extended blue chalcedony, for example, looks like it might begin to glow at any moment, a force for good. Slowly and silently, this floating city might begin to move into space toward an unknown destiny.

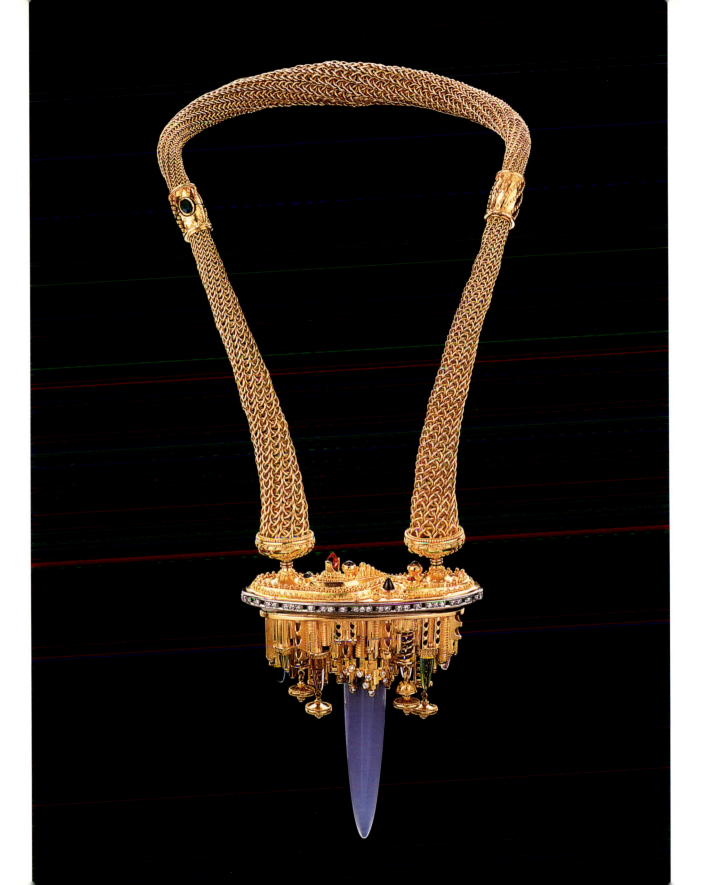

ED ROSSBACH

1914–2002

San Blas

1967, cotton
and linen
72 x 70 in.
Smithsonian
American Art
Museum, Gift of
Lisa and Dudley
Anderson

The San Blas Archipelago is a string of approximately four hundred tropical islands off the Caribbean coast of Panama. The San Blas islands are famous for colorful *molas,* the traditional blouse worn by the women of the Kuna Indian tribe, who are native to the region. Only the women, using a reverse-appliqué method, handstitch the bright cotton panels. Ed Rossbach's *San Blas* textile pays tribute to the Kuna's cultural fiber tradition. As we study this vibrant wall piece, it becomes clear that color is the content of *San Blas.*

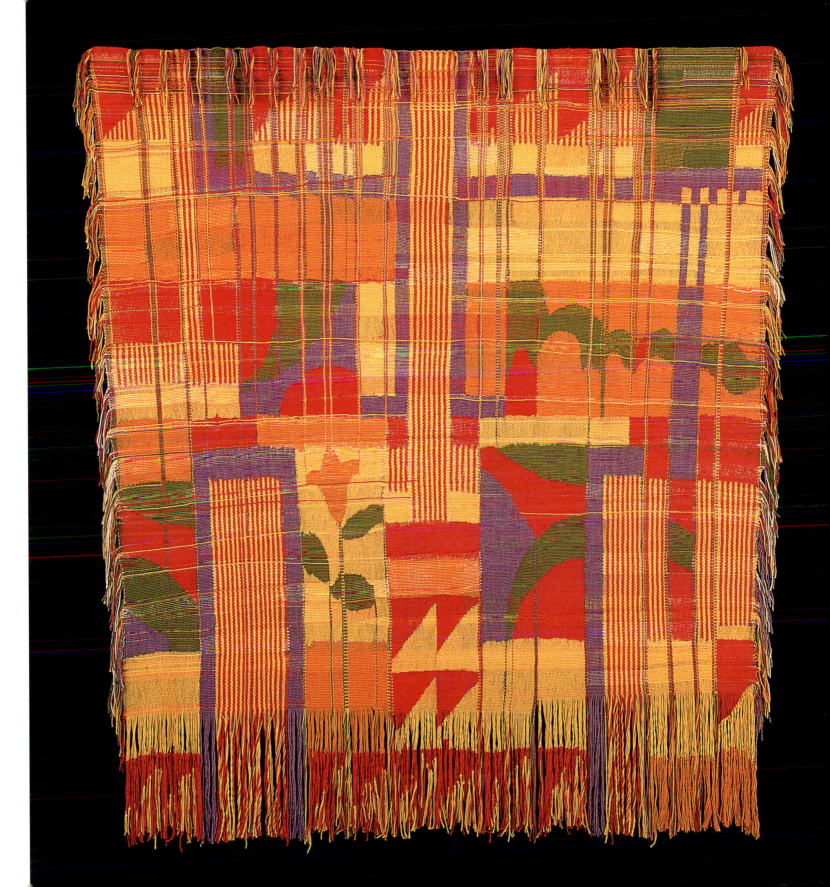

CYNTHIA SCHIRA

born 1934

Table/Cloth

1998, linen
and cotton
48 x 41 ⁷⁄₈ in.
Smithsonian
American Art
Museum, Gift of the
artist in memory of
Patti Zoppetti

Despite its title, *Table/Cloth* is not a woven textile used to cover a table but a work of art meant to be hung on a wall. Still, the piece alludes to the long-established tradition of loom weaving and to domestic textiles that enhance daily life or are significant in such rituals as family gatherings at holidays or in religious ceremonies.

Since 1983 Cynthia Schira has employed a computer-assisted loom and design software to create her complex textiles. *Table/Cloth* is the second in a three-part series, *Drawing on Tradition,* that expresses her interest in joining functional textiles and fine art. Dramatic in vivid colors and pulsating energy, the weaving reflects the artist's fascination with textile traditions and art forms from around the world. The flower in the piece derives from an old South Asian chintz cloth; the squares are taken from Japanese indigo fabric; and the lines are copied from a drawing by the artist's husband. *Table/Cloth* weds women's culture in the home, in which textiles play such an important part, with the intent and content of art.

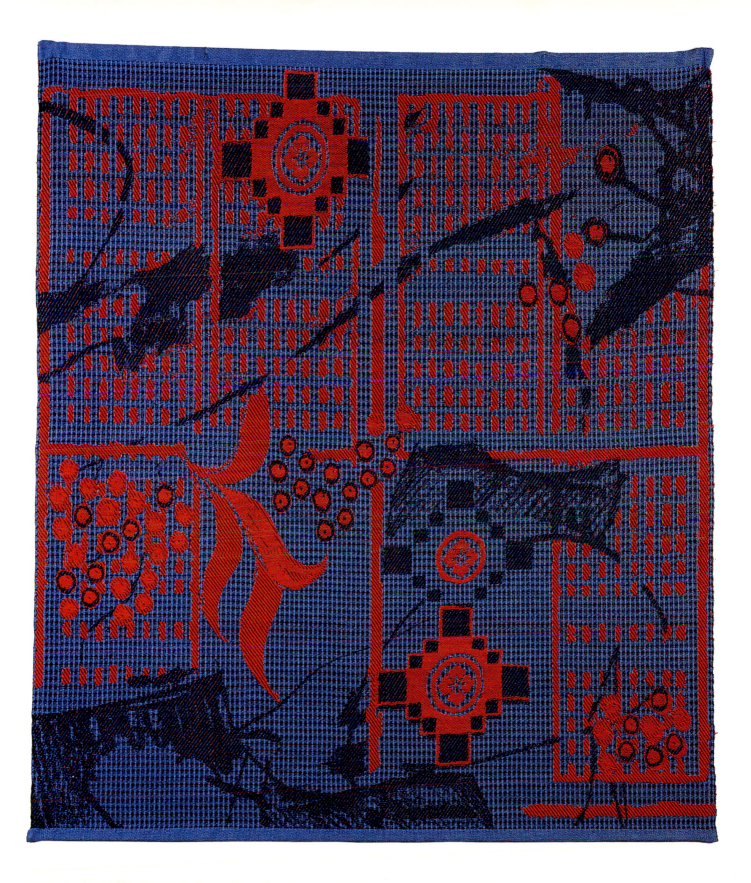

HEIKKI SEPPÄ

born Finland 1927

Lupin Wedding Crown

1982, gold, silver, and diamond
4 x 8 x 8 in.
Smithsonian American Art Museum, Gift of the James Renwick Alliance

Finnish-born Heikki Seppä is known for his innovative metalsmithing techniques and clean designs. *Lupin Wedding Crown* is made of thin-gauge silver sheets soldered to create a lightweight hollow form. The crown is composed of a series of swirls that loop around and through themselves, ending in a spray of gold honeycomb flowers. Lupin is a wildflower in the pea family. Because it is a rich food source, it is a symbol of abundance and fertility.

A lupin wedding crown refers to the Finnish wedding custom called "The Dance of Crowns." During the reception, a bride, wearing a gold crown, is blindfolded and her single bridesmaids dance around her in a circle. She then removes her crown and places it on the head of one of the women—whoever is crowned would be the next to marry.

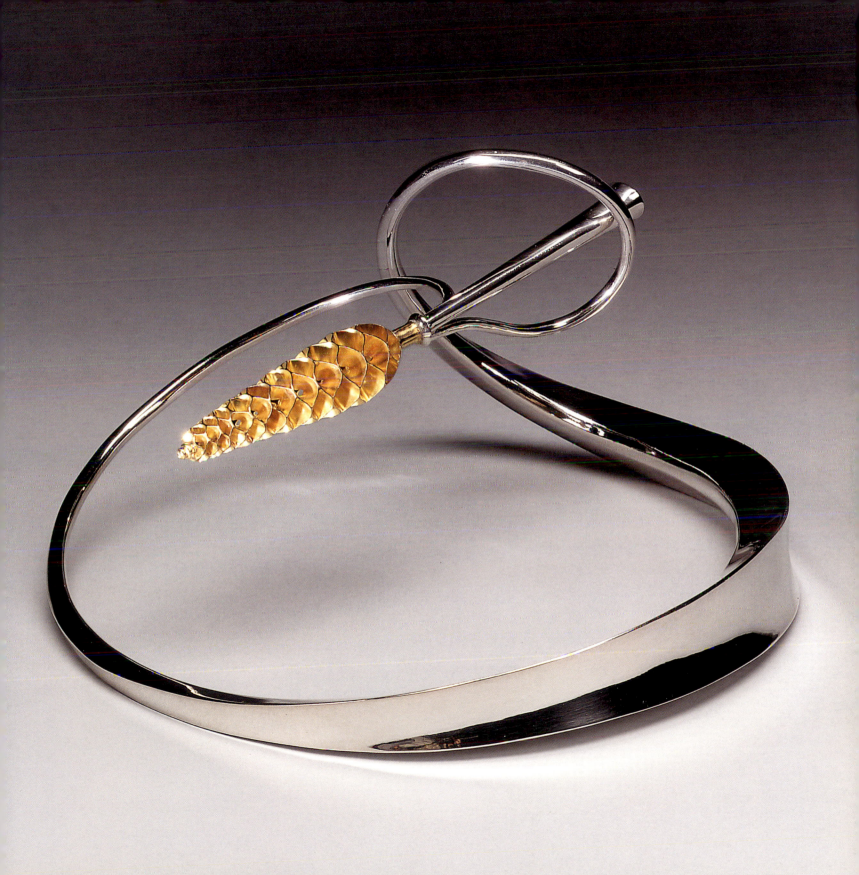

ROBERT SPERRY

1927–1998

Plate #753

1986, stoneware
with white slip
4 x 27 ⅝ in.
Smithsonian
American Art
Museum, Gift of the
James Renwick
Alliance

The dynamic interplay of circles, arcs, and broad gestural strokes of this plate suggest a celestial chart and recall Pythagoras's lyrical phrase "music of the spheres." The ancient Greek philosopher believed that the movement of the planets produced notes so perfectly harmonious and exquisite that the music was inaudible on Earth. Sperry's imaginative use of circles and flowing lines imbues the decorative pattern with rhythmic, pulsating energy. Abandoning color in favor of contrasting black and white, he enriches the pastelike glaze with various textures.

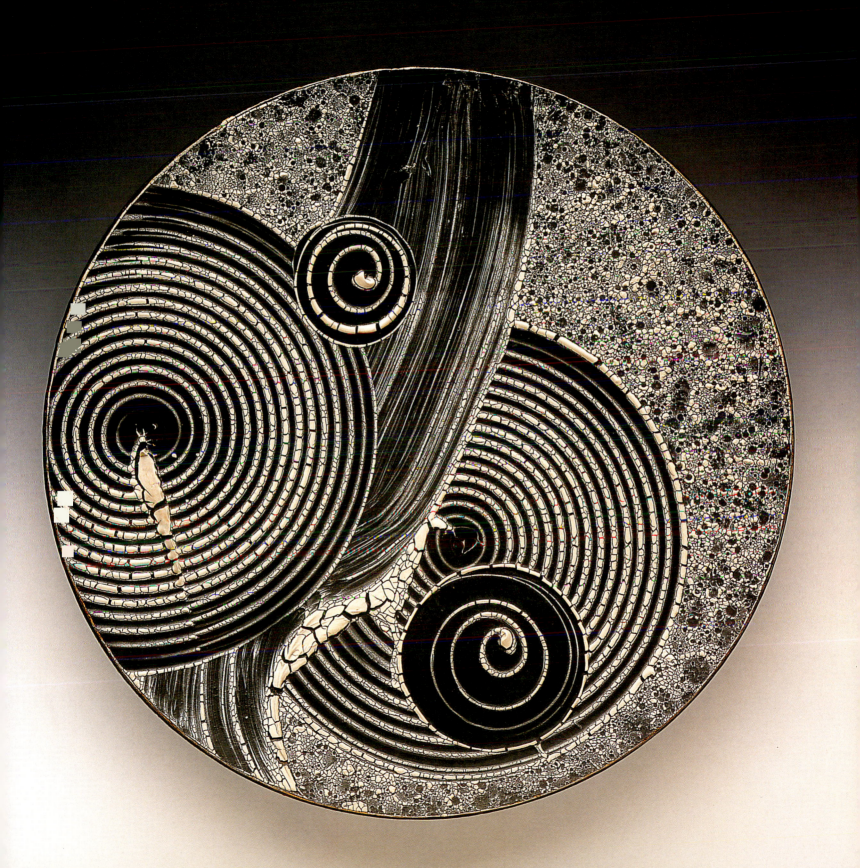

THERMAN STATOM
born 1953

Arabian Seasons

1994, glass with
mixed media
42 ½ x 36 x 4 ⅝ in.
Smithsonian
American Art
Museum, Gift of the
James Renwick
Alliance and
museum purchase
made possible by
the Smithsonian
Institution
Collections
Acquisition Program

Therman Statom uses industrially produced plate glass to create a large wall-hung box for his miscellaneous array of objects and his expressive painting and drawing. *Arabian Seasons* is part of the tradition of assemblage in which artists gather unrelated found objects and present them in a new context. The seven-of-clubs playing card, rock, map of Denmark and northern Germany, tree branch, dice, magnifying glass, and glass rods possessed histories and associations before they were married in this arrangement, which gives them new meaning.

Arabian Seasons can be enjoyed and contemplated for its composition, colors, textures, and play of light, and for the associations that each object conveys. The rock and the tree branch denote the natural world, whereas the glass rods refer directly to the history of glass. Maps are metaphors for personal journeys and an identification with one's place in the world. Dice have long been associated with chance and are a symbol of life's unpredictability. Although these readings may not be what the artist intended, in the absence of a detailed outline of the content, we are left to reach conclusions based upon a shared knowledge of symbols in our culture.

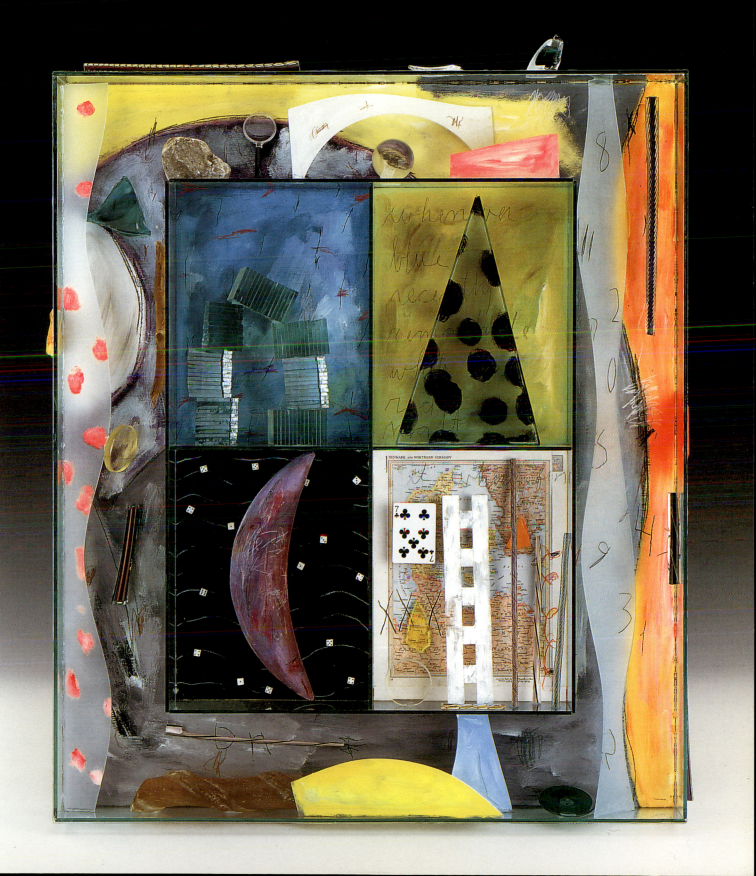

BOB STOCKSDALE

1913–2003

Bowl

1987, Moroccan
thuya wood
4 ³⁄₈ x 11 ¹⁄₄ in.
Smithsonian
American Art
Museum, Gift of
Jane and Arthur K.
Mason

Bob Stocksdale's lathe-turned bowls are simple, restrained forms of exquisite proportions and beautiful woods. A leading figure in the contemporary wood-turning movement, Stocksdale celebrates the beauty of wood. Because all woods have unique properties, he prefers to let the wood itself dictate how it will be worked. Stocksdale's turned bowls make no reference to the world beyond themselves. That is, each finished bowl offers no comment or content beyond its own purity.

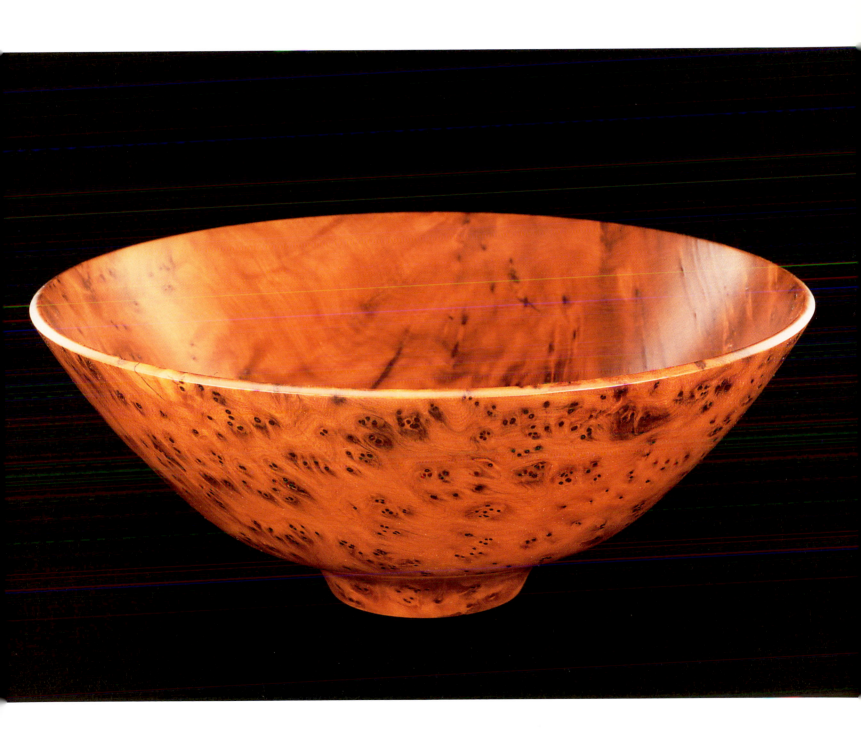

VALERI TIMOFEEV

born Latvia 1941

Chalice

1995, silver, gold
plate and foil,
garnets, pearls,
turquoise,
hematite, tiger's
eye, filigree wire,
and plique-á-jour
enamels
7 ⅝ x 6 in.
Smithsonian
American Art
Museum, Gift of the
James Renwick
Alliance

A Latvian-born immigrant, Valeri Timofeev spent years in Moscow reviving and perfecting plique-á-jour, an enameling technique that had almost disappeared after the 1917 Bolshevik Revolution. The process involves suspending a delicate layer of colored glass between the openings of a wire framework, giving the glass a beautiful translucence. Invited to work in the United States in 1991, Timofeev found opportunities in America that led to his permanent move in 1993. Today, his plique-á-jour is unsurpassed for its artistic brilliance and technical skill. Conjuring images of royal ceremonies and sacred Eastern Orthodox rituals, Timofeev's chalice embodies the dignity, beauty, and opulence of a state treasure and the grandeur of a sacred artifact. Glittering with gold and semiprecious gemstones and bursting with color as light shines through the glass, it is a timeless work of art that serves as an intermediating force between heaven and earth.

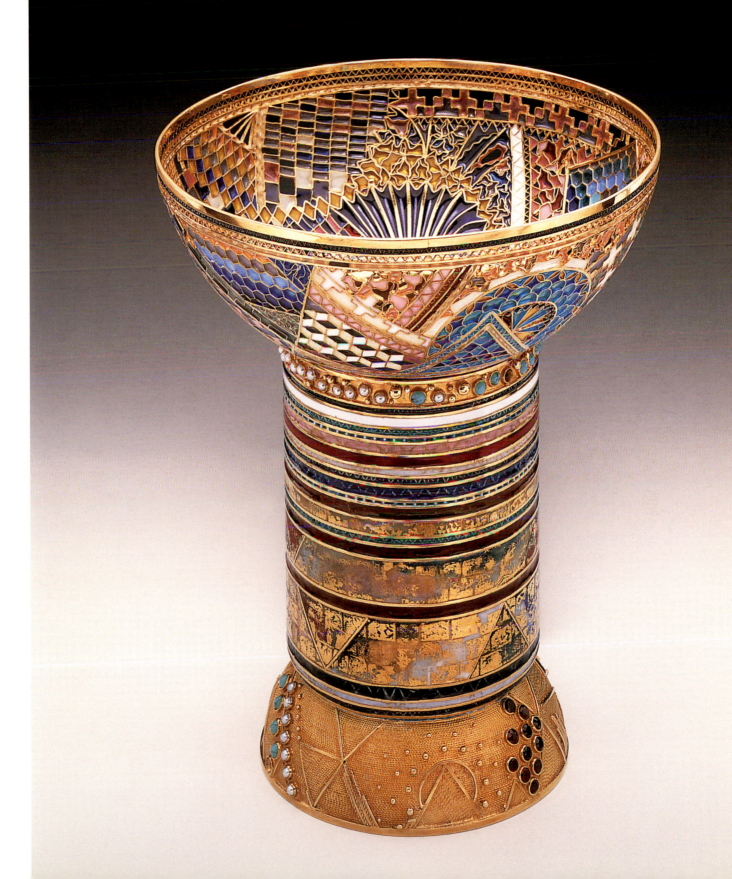

PETER VOULKOS

1924–2002

Rocking Pot

1956, stoneware
13 ⁵⁄₈ x 21 x 17 ½ in.
Smithsonian
American Art
Museum, Gift of the
James Renwick
Alliance and various
donors and
museum purchase

Peter Voulkos's *Rocking Pot* is not a pot, and it does not rock. The piece is a dynamic sculpture that straddles the tradition of functional pottery and pure sculpture. It was made using the time-honored technique of throwing—the raising up of an object on the potter's wheel. Voulkos reinforced the earthiness of the clay by avoiding glaze, color, or metallic finishes.

Rocking Pot is composed of an inverted helmetlike "pot" pierced by fourteen circular openings. The sculpture rests on two curved runners. Four other curved blades puncture the body: two are parallel to the base blades and two are set at right angles to the base. The spontaneity of the piece is most evident in the free-form cuttings of the openings. The result is a sculpture of compelling presence. *Rocking Pot* suggests an object used in sacred rituals or perhaps one whose function has been lost in time.

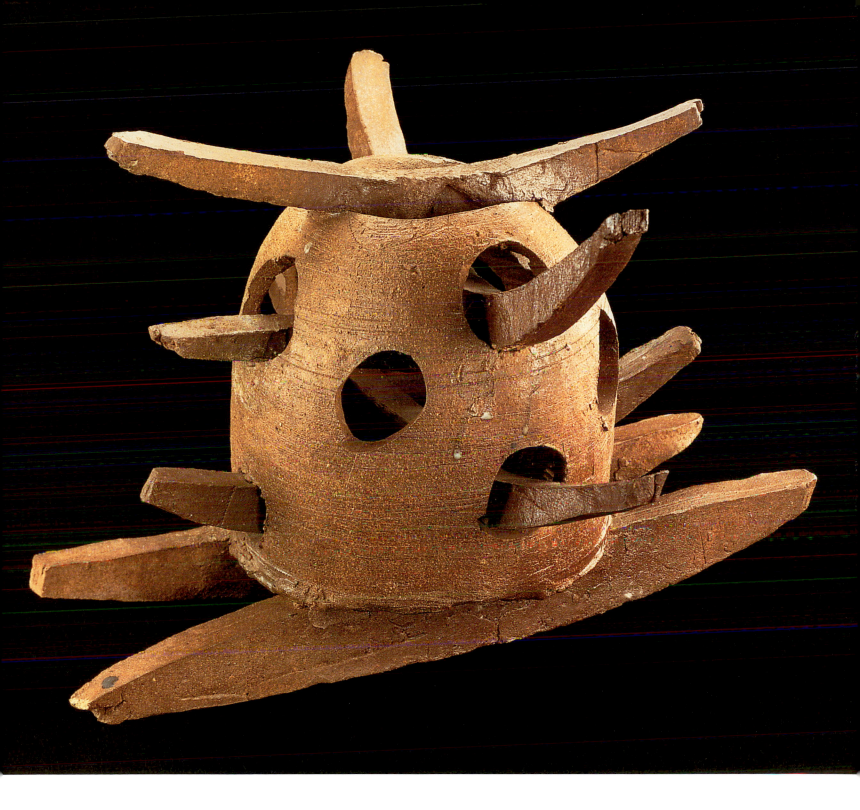

BEATRICE WOOD
1893–1998

Tides in a Man's Life

about 1988
earthenware
11 ½ x 5 ½ in.
Smithsonian
American Art
Museum, Gift of
Kenneth R. Trapp
in honor of
Shelby M. Gans
on the occasion of
her appointment to
the Board of
Commissioners of
the Smithsonian
American Art
Museum

Created about 1988, when the artist was ninety-five years old, *Tides in a Man's Life* is one of Beatrice Wood's most accomplished works. Of special interest is the brilliant gold-luster glaze for which the artist achieved international renown. The glaze varies from what looks like liquid gold to iridescent patches of purple and lime green. As light plays across the piece, the glaze appears to shimmer with fire and constantly transform itself.

Although Wood never explained the title of this piece, it can be read as a metaphor for the stages of human struggle and attainment. At the left, an exhausted man hangs onto the bell-shaped body of the piece. At the right, one figure helps another to gain his footing for his climb upward. Finally, a man stands triumphant on top of the ring handle. Wood's sculpture has the elegant presence of a trophy.

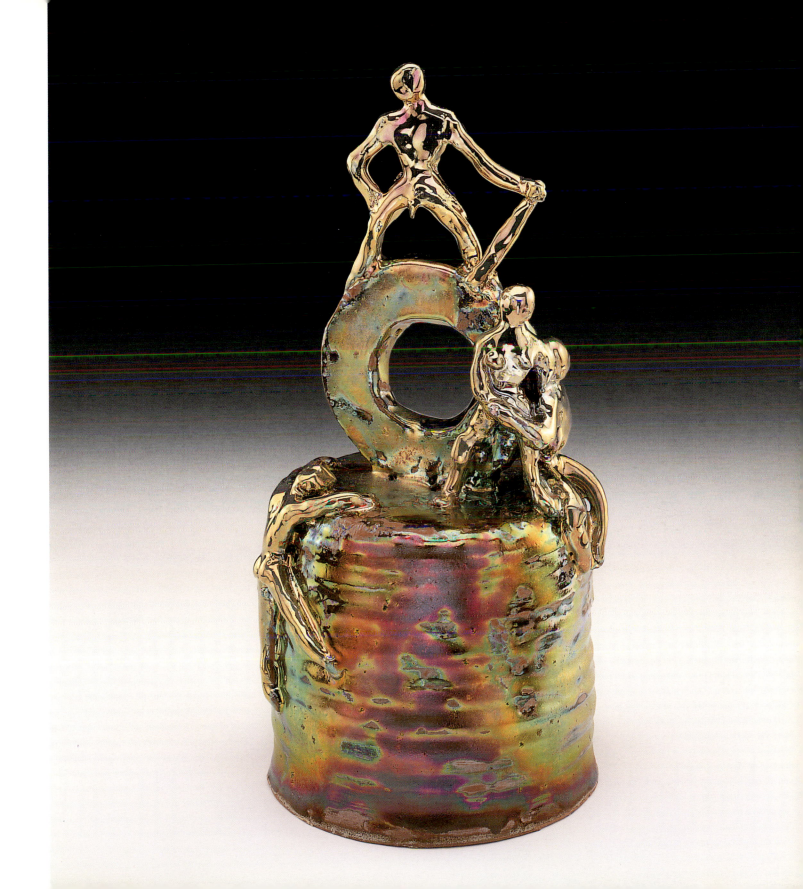

BETTY WOODMAN

born 1930

Kimono Vases: Evening

1990, earthenware
31 x 22 ½ x 8 ½ in.;
and 31 x 23 ½ x 8 ½ in.
Smithsonian
American Art
Museum, Gift of the
James Renwick
Alliance
and museum
purchase made
possible by the
Smithsonian
Institution
Collections
Acquisition Program

Betty Woodman investigates the phenomenon of the progression of sunlight in the guise of two tall vases, part of a series that addresses various times of day and night. One side is glazed with dark colors reminiscent of evening, and the other has pastel hues evoking dusk or dawn. The artist energizes the static lines of the vases by applying forms that suggest flowing kimono sleeves. When displayed, these works create lively spatial exchanges.

Like many artists in contemporary craft, Woodman draws freely from the past and from other cultures for inspiration. Here, she uses the tradition of Italian majolica painting—tin-glazed earthenware painted with tin solutions—to create a brilliant chromatic effect. She is sometimes called a "natural painter." Although these vases are rooted in the vessel tradition, the artist lifted their forms from classic Japanese costumes and textiles. In Woodman's hands past and present merge to create an art that is distinctive to its maker.

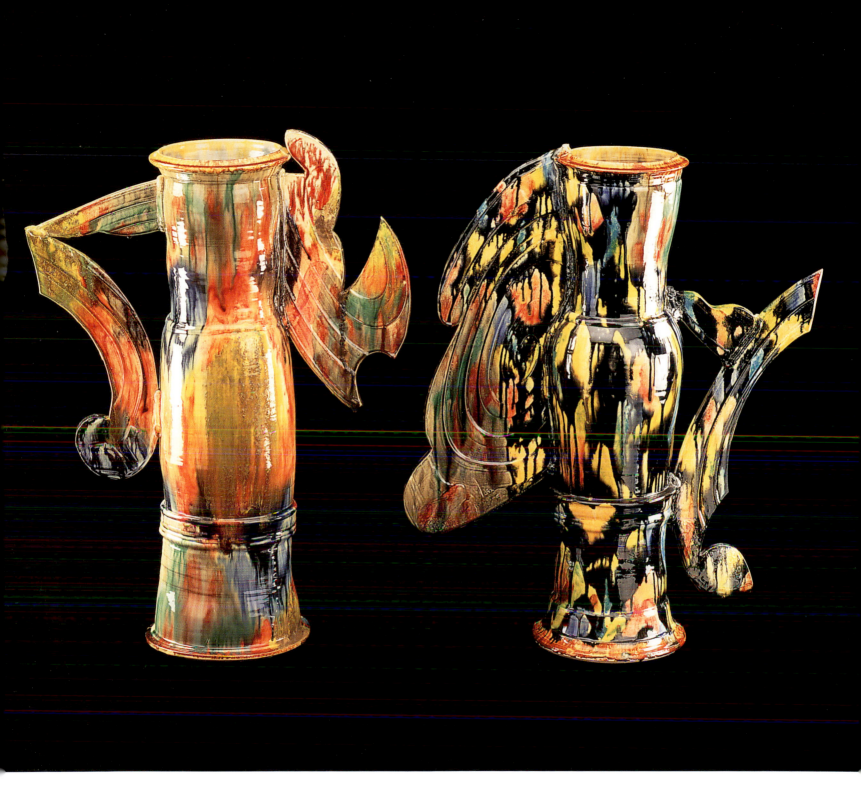

RICK WRIGLEY

born 1955

The Rick Wrigley Renwick Cabinet

2001, various
tropical hardwoods,
marble, and brass
40 x 46 x 22 in.
Smithsonian
American Art
Museum, Gift of the
James Renwick
Alliance

Rick Wrigley and his assistants designed and made this cabinet specifically for the Smithsonian American Art Museum's Renwick Gallery. The piece was inspired by a sideboard made by Thomas Hook of Salem, Massachusetts, in 1808–1809 in the Museum of Fine Arts, Boston. Although indebted to Hook for his design, Wrigley does not slavishly copy the early model; instead, he infuses historical tradition with his own creative spirit.

Wrigley is a master craftsman whose use of veneer, inlay, and marquetry is unsurpassed. Like a painter carefully arranging his palette, he chooses exotic woods for their distinctive characteristics of figuring, grain, color, and density. Here, for example, the primary veneer is *pomelé sapelé*, a Honduran cocoa-brown mahogany with a pronounced figured pattern. The wood is lustrous and suggests depth.

The decorative design of the drop front honors Washington, D.C., in the flying eagles attacking snakes and the arching garland of olive branches. The eagles and snakes symbolize the battle between good and evil.

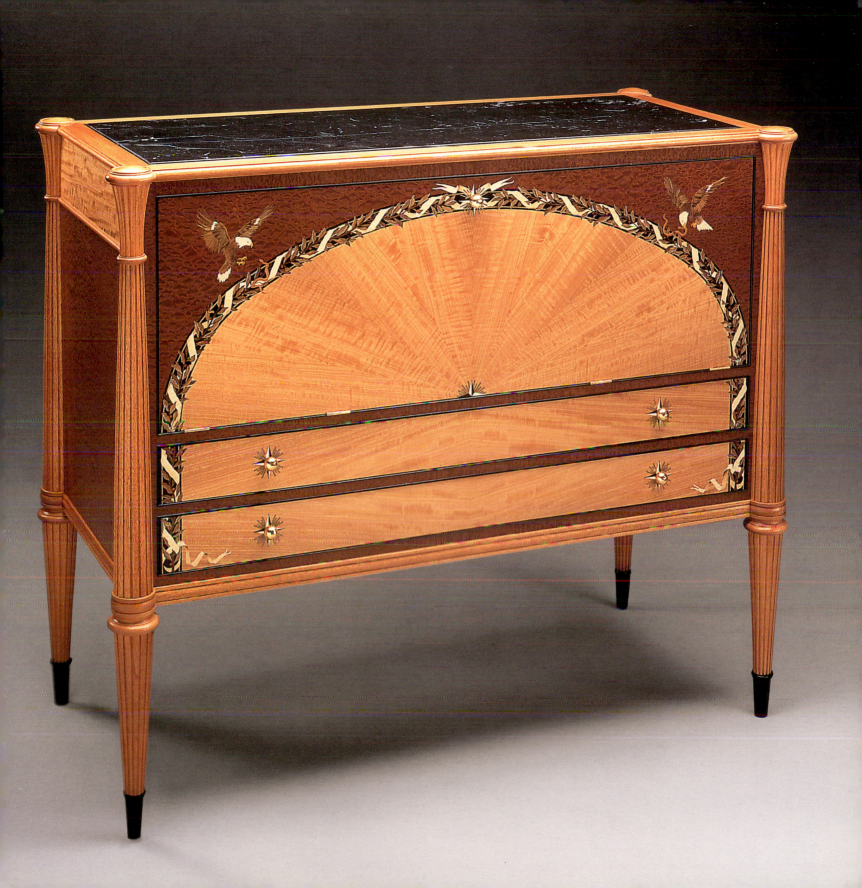

Index of Titles

The Smithsonian American Art Museum is dedicated to telling the story of America through the visual arts. The museum, whose publications program includes the scholarly journal *American Art*, also has extensive research resources: the databases of the Inventories of American Painting and Sculpture, several image archives, and fellowships for scholars. The Renwick Gallery of the Smithsonian American Art Museum is the nation's premier museum of modern American decorative arts and craft. For more information, write to: Office of Publications, Smithsonian American Art Museum, Washington, D.C. 20560-0970. The museum also maintains a Web site at **AmericanArt.si.edu**